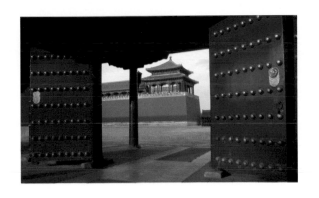

ABBEVILLE PRESS

NEW YORK LONDON

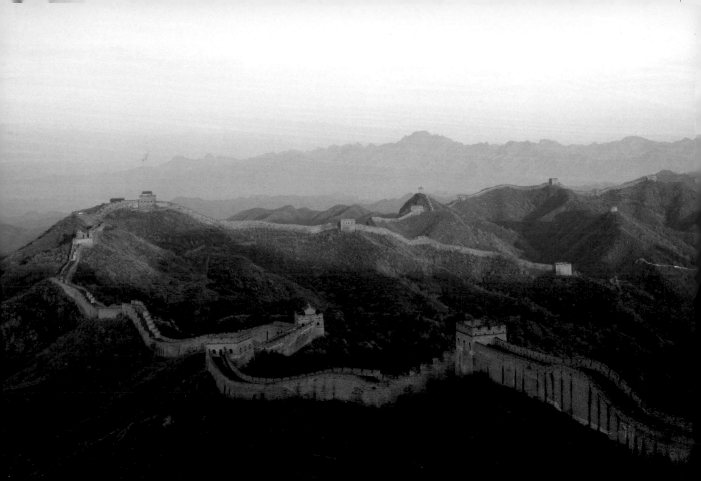

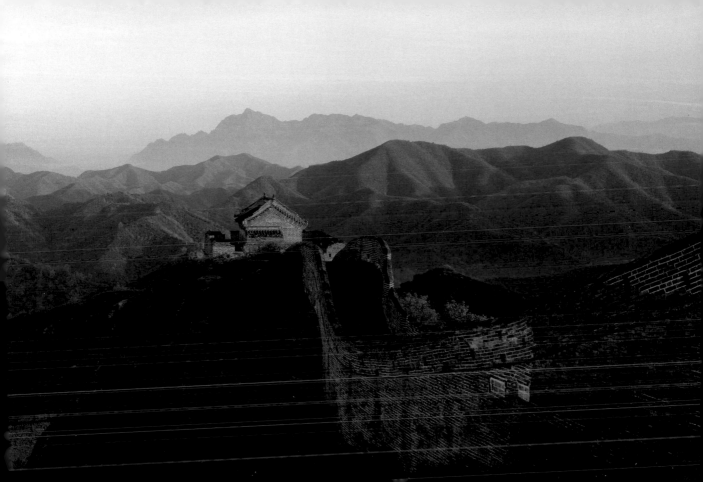

中国 Ch

IINA

A PHOTOGRAPHIC JOURNEY
THROUGH THE MIDDLE KINGDOM

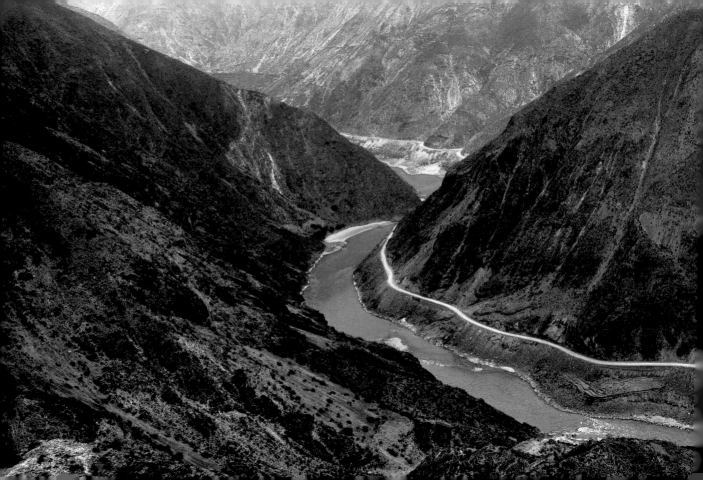

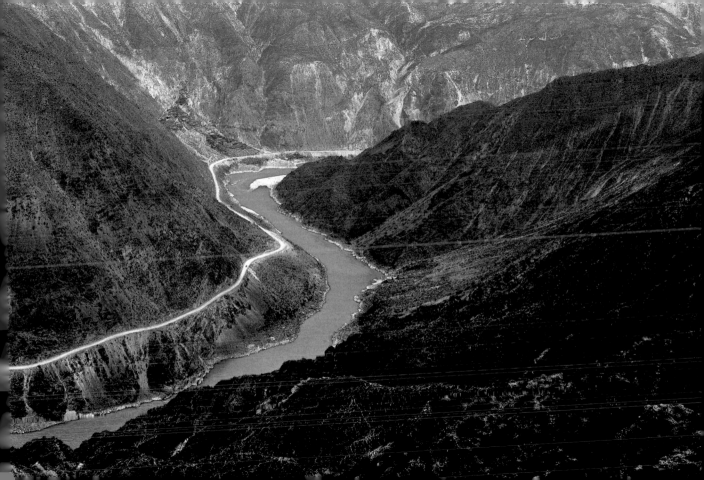

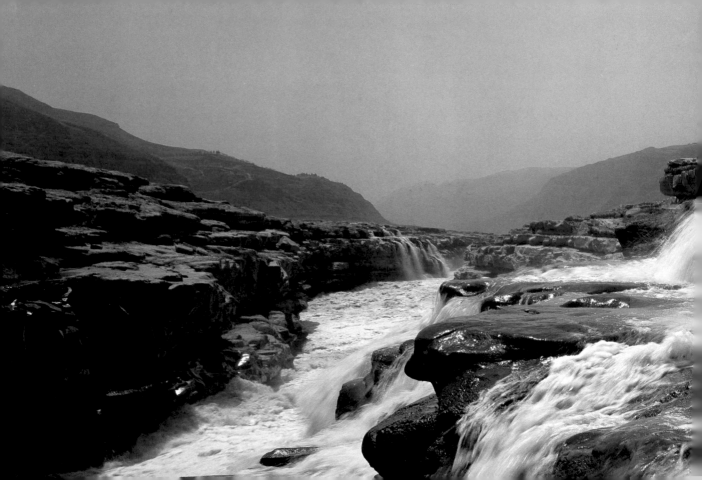

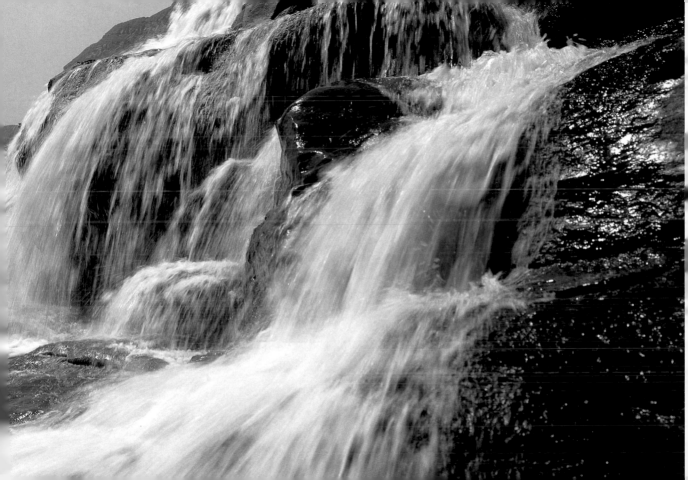

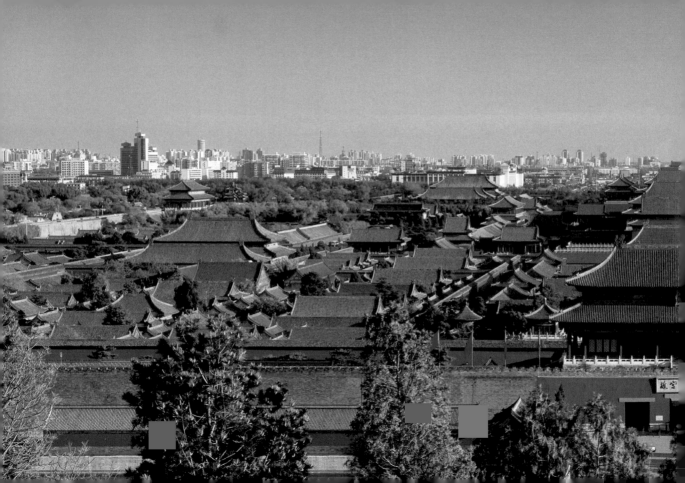

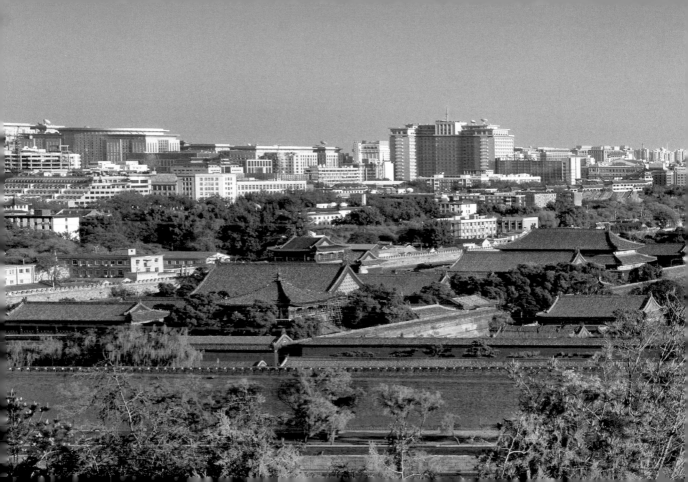

FOREWORD

What is China really like? It all depends on how you look at it. On the one hand, China is very ancient; its great river of civilization has been flowing freely for several thousand years. On the other hand, China is very young; its cities, towns, and villages brim with youthful energy amidst all the pressures of life. China looks majestic; its sublime natural landscapes are filled with tall mountains, wide rivers, and deep valleys. And China also looks lovely; its elegant gardens and picturesque rural views speak volumes about the Chinese people's desire for an idyllic life. This country, so vast and so full of contradictions, bears witness to the all-encompassing quality of Chinese culture and its ideal of "Universal Harmony."

The ancestors of the Chinese people left behind a wealth of gifts. The grand and glorious Yungang Grottoes show how Buddhist art, which was executed in the Indian and Persian styles when it was first introduced to China, was gradually accepted and assimilated into Chinese culture. The Forbidden City derives its unique splendor less from its individual buildings than from the grandeur and harmony of its entire architectural ensemble, which is meticulously laid out in accordance with functional and symbolic principles. The Temple, Cemetery, and Family Residence of Confucius, which make up a huge architectural complex as impressive as the Forbidden City, echo the spirit of hierarchy and balance inherent in the Confucian "Doctrine of the Mean." Mysterious, magnificent, or beautiful as they are, these monuments are all miracles of the human spirit. They embody the fundamental elements of Chinese tradition, which emphasizes unity and

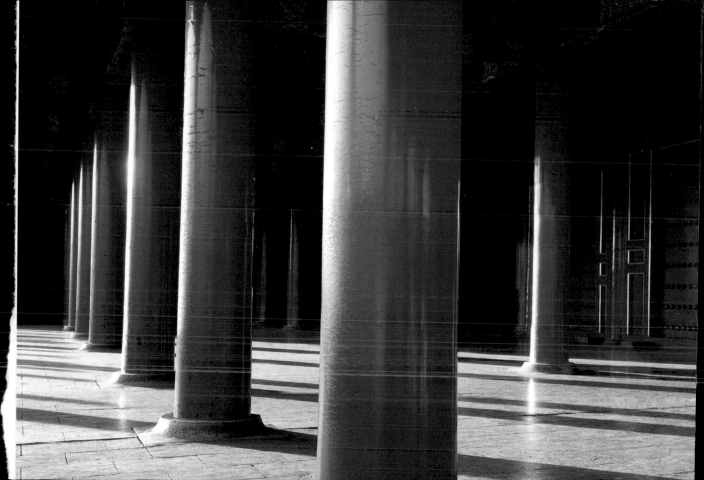

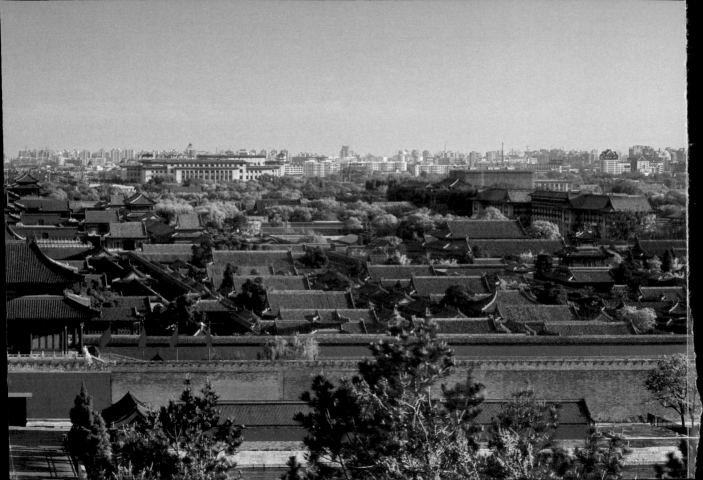

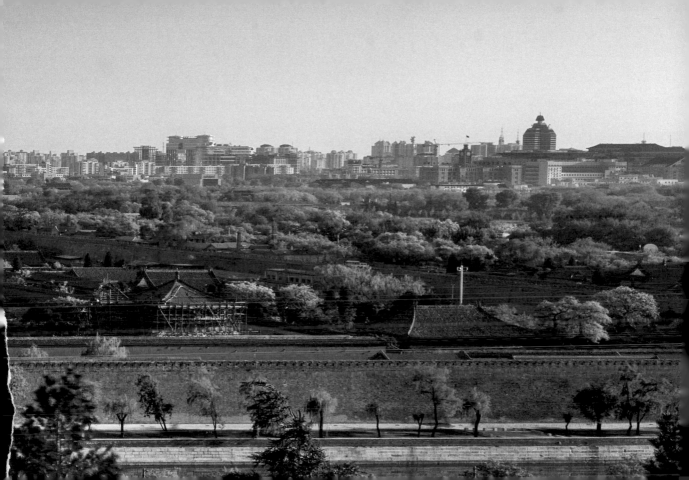

harmony, an ethical balance, and a welcoming heart that embraces all, as the sea accepts all rivers.

Some other sights in China are wonderful examples of the harmonious coexistence of man and nature: the Yuanyang terraced fields, the result of a handshake between the power of the Earth and the strength of man; Xidi and Hongcun, part of a string of small towns, villages, and hamlets created by the touch of human fingers as they brushed along the corners of the countryside; or the classical gardens of Suzhou, "man-made mountains and forests within the city wall." The color and beauty that have been added to the already gorgeous natural landscape by the activity of man are a graphic illustration of the dynamic energy of Chinese culture.

Mother Nature has specially favored the Middle Kingdom, whose vast territory encompasses a great diversity of landscapes and numerous breathtaking natural wonders. In China, you can see the dreamlike cloudscapes of Mount Huangshan, hear the thundering of the Three Parallel Rivers, breathe the fresh air in Huanglong and Jiuzhaigou valleys, and even feel the winds whistling past the summit of Mount Everest.

This book illustrates forty-four of China's greatest cultural attractions and natural landscapes, including twenty-eight World Heritage Sites. We hope that while leafing through these pages, you will appreciate not only the power of Chinese culture, history, and tradition, but also the rich legacy created by Nature and left to all of us by the Chinese ancestors. Take your time, tour the sites, and experience the wonders that belong not just to China, but to the whole world.

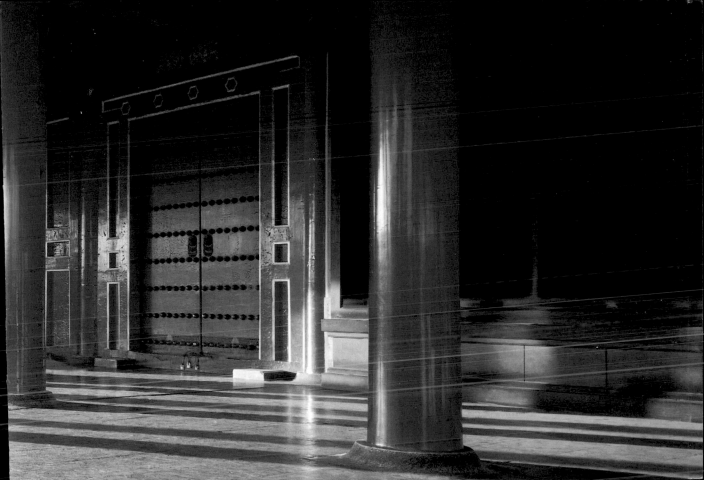

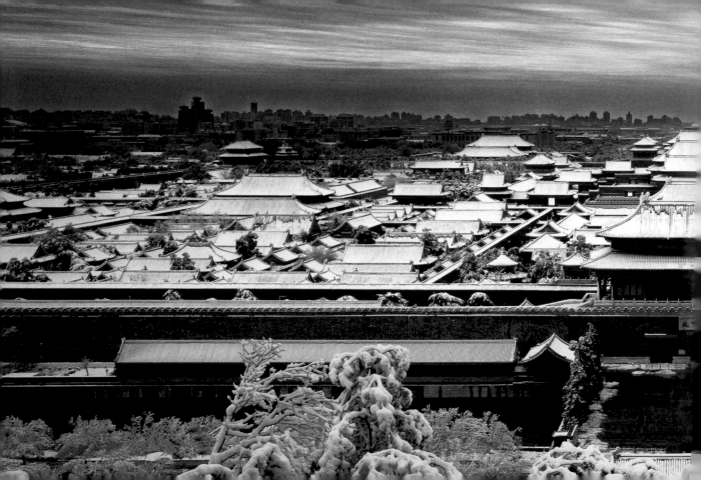

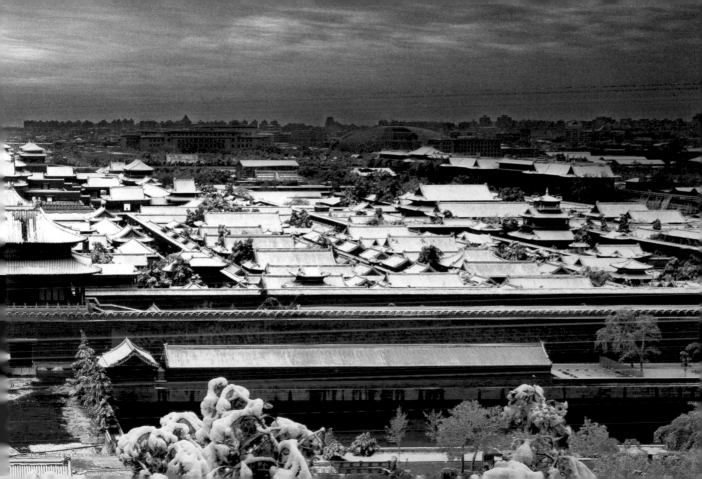

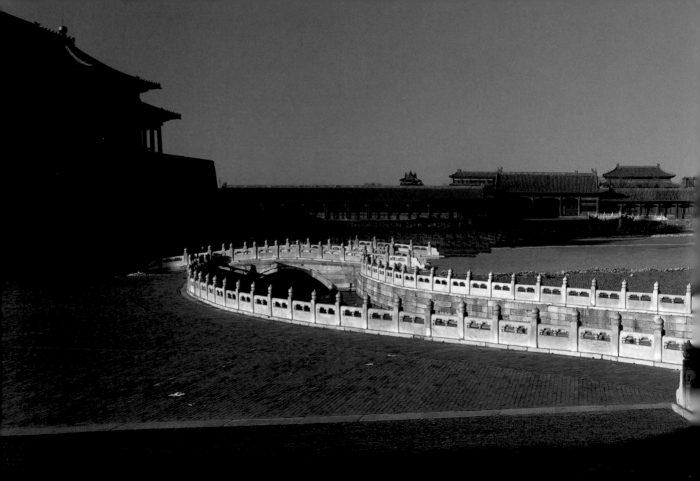

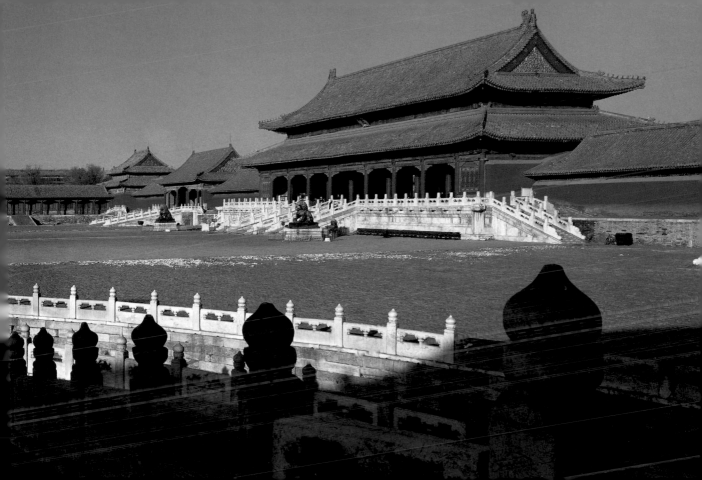

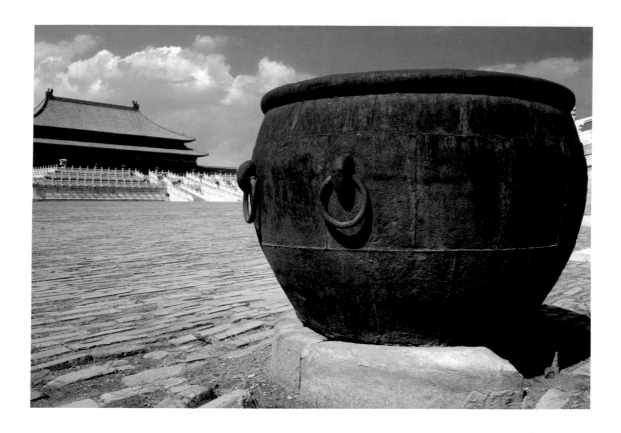

22

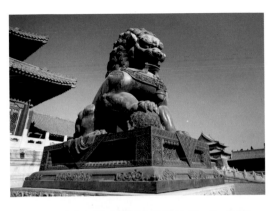
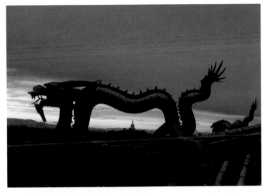

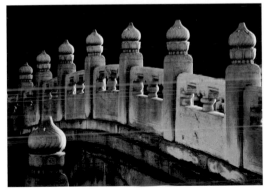
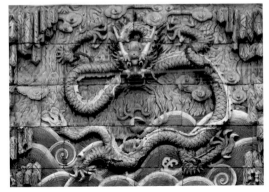

24

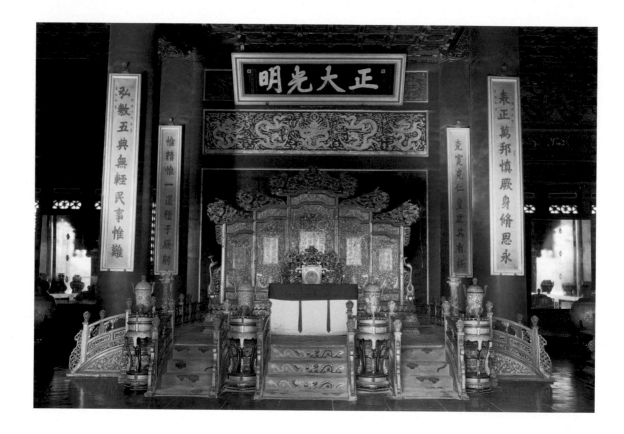

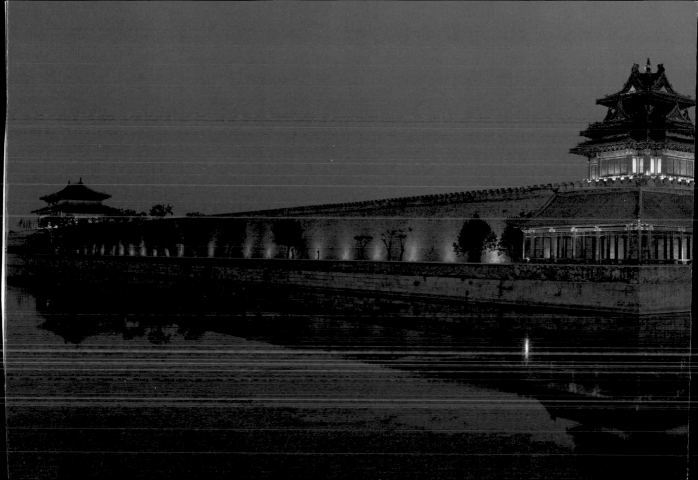

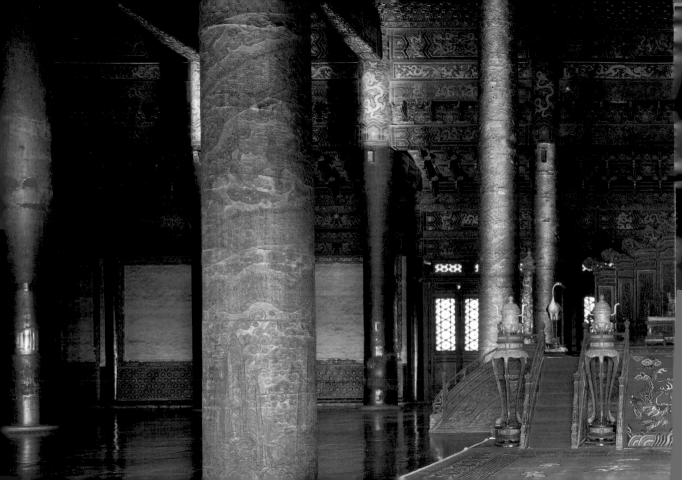

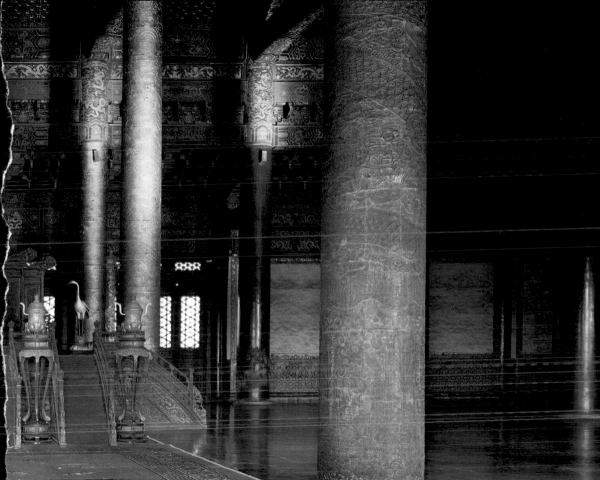

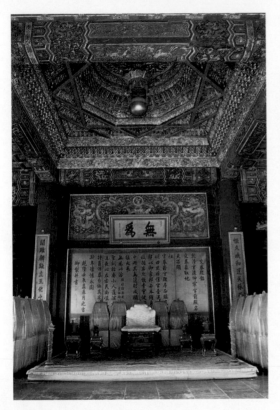

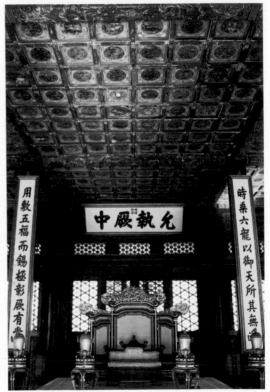

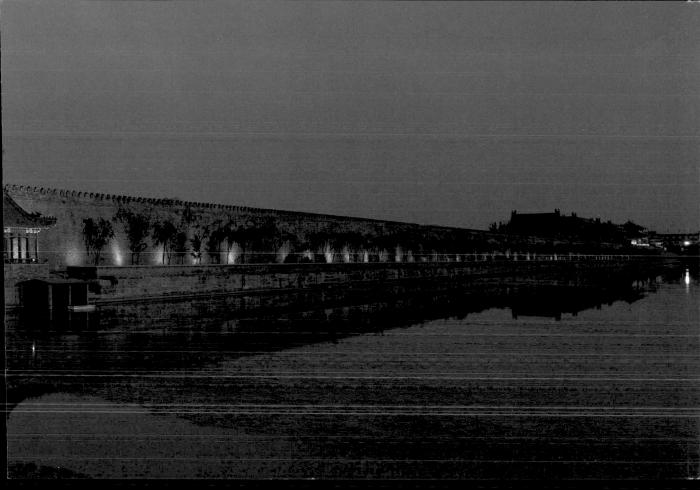

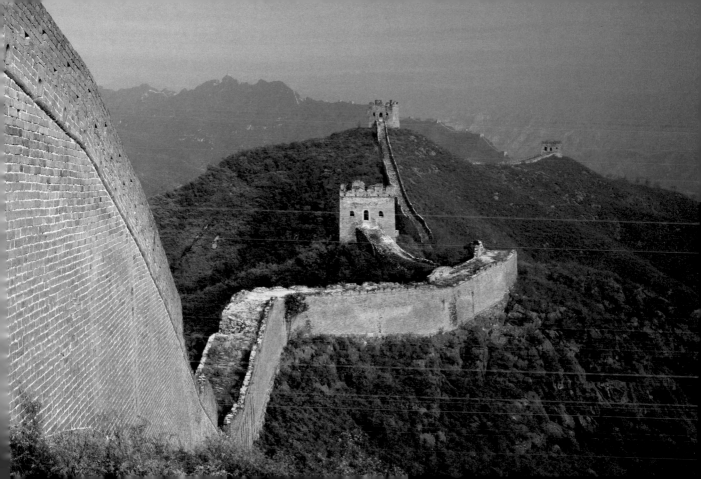

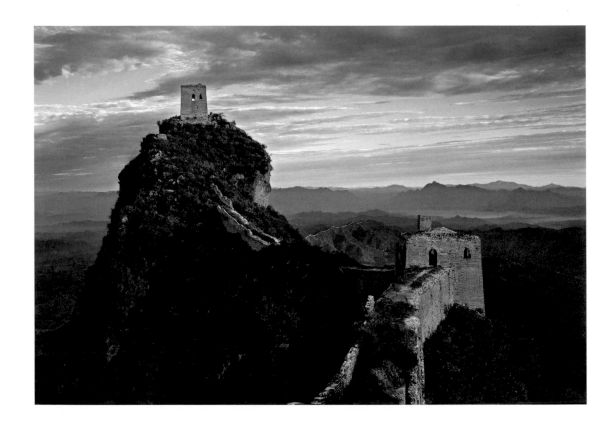

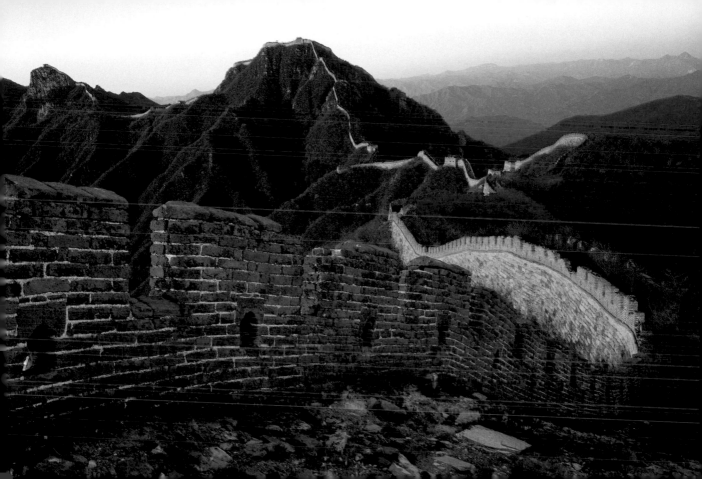

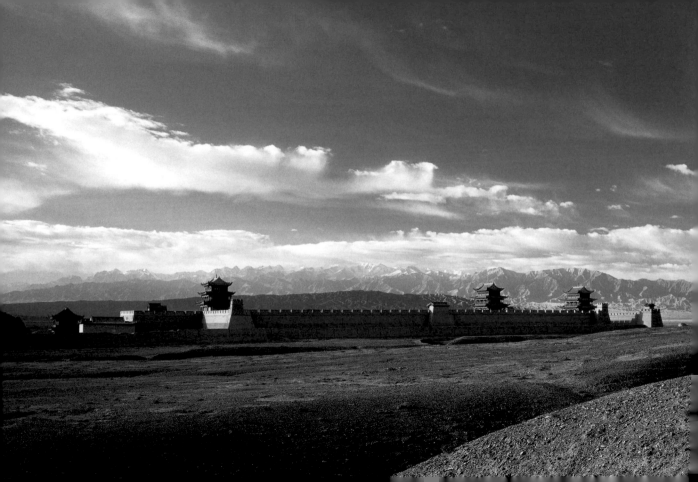

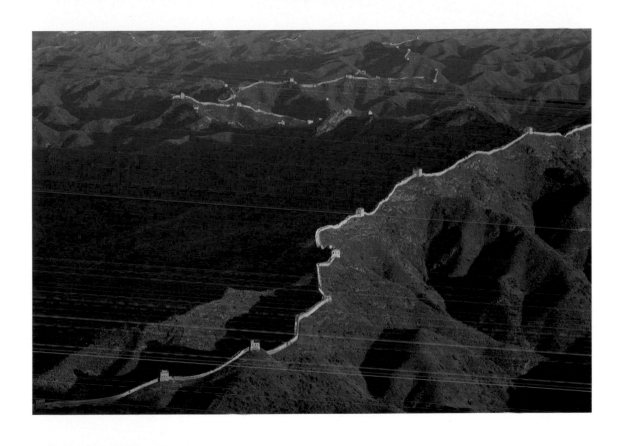

35

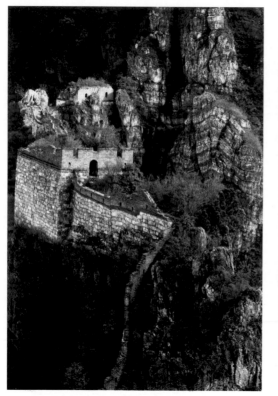
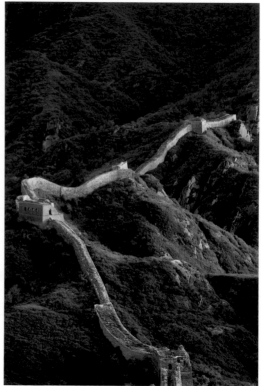

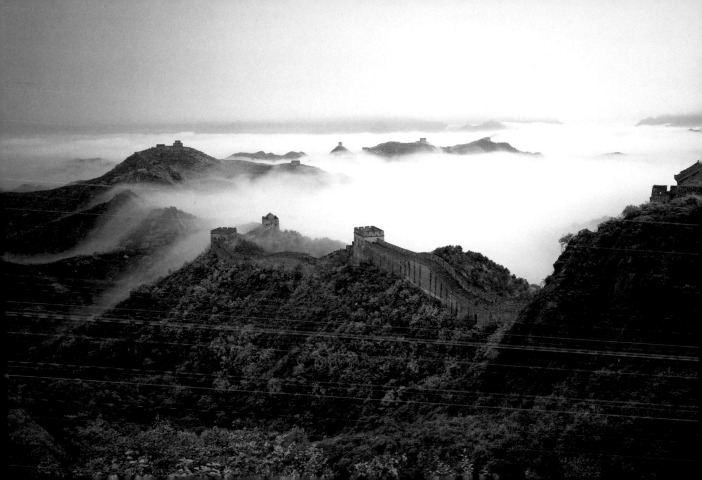

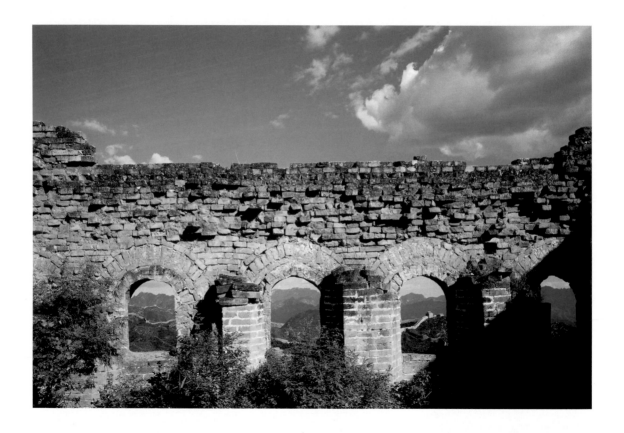

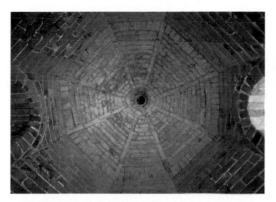

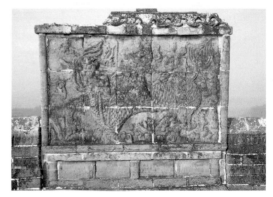

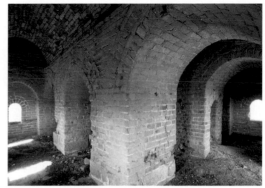

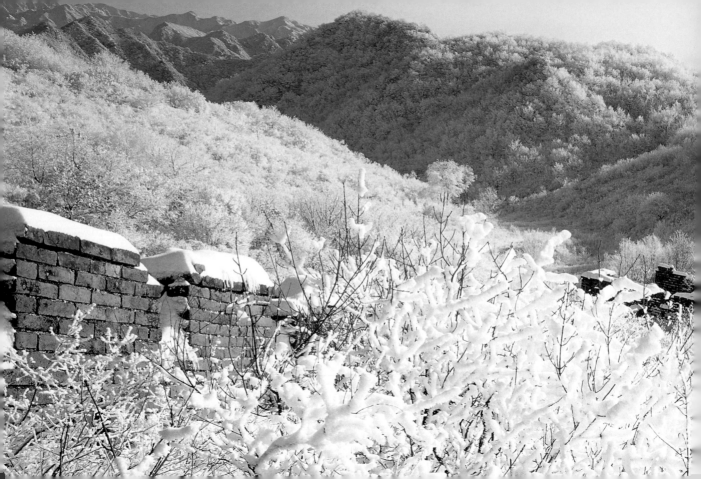

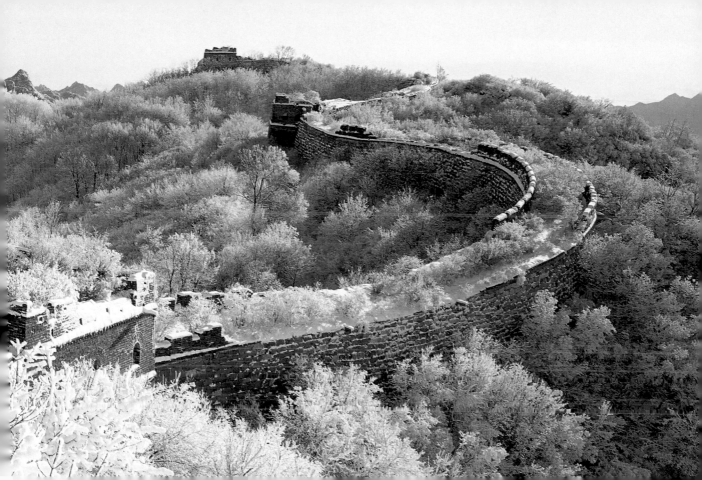

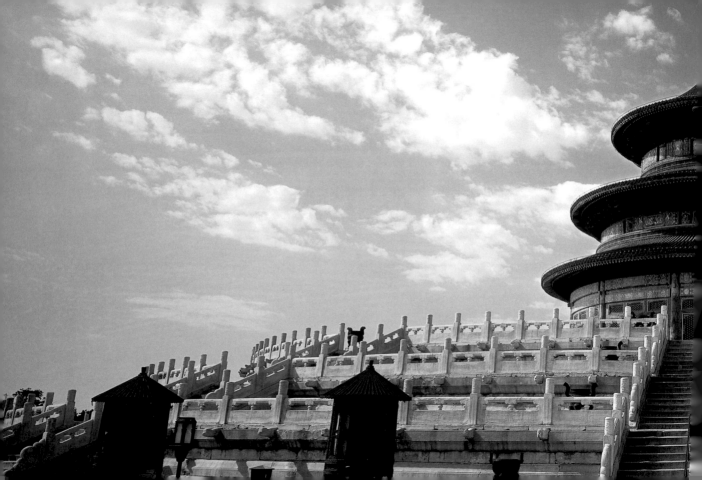

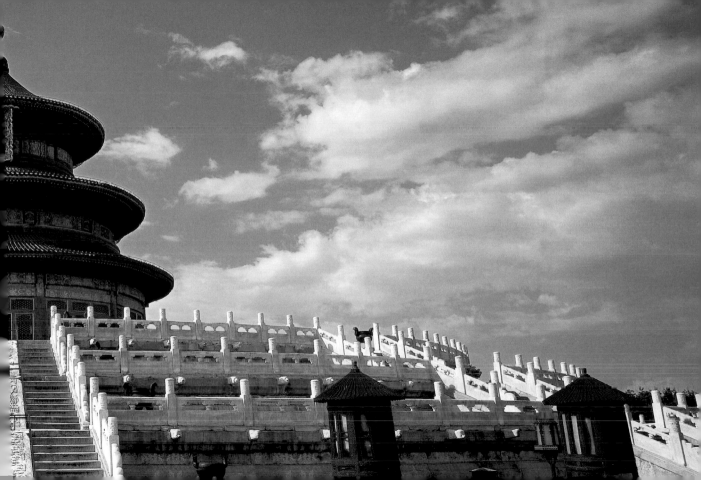

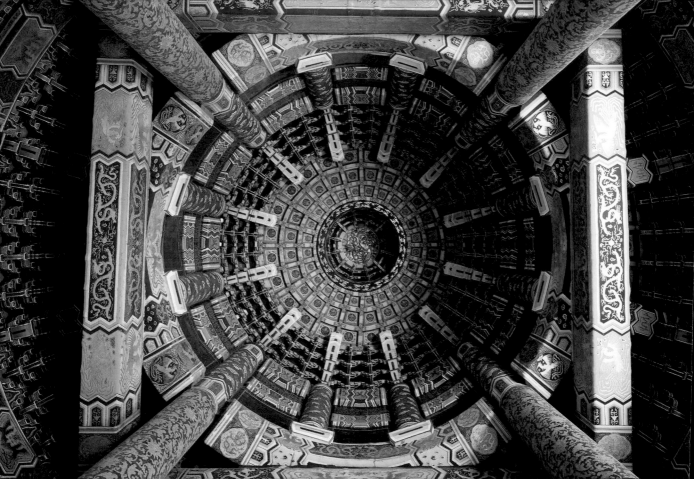

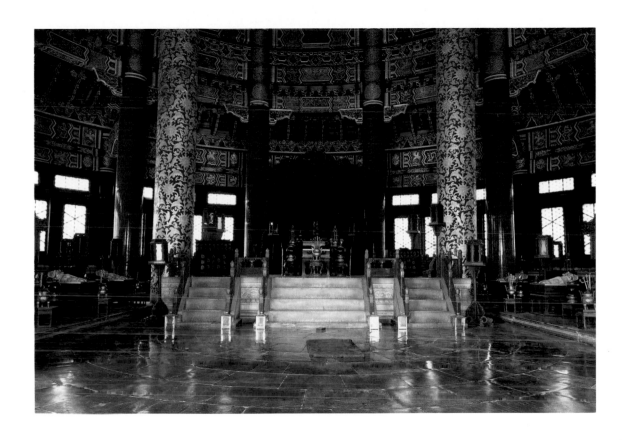

45

46

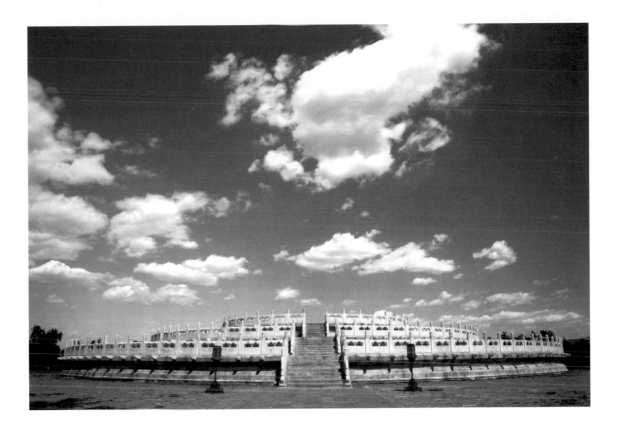

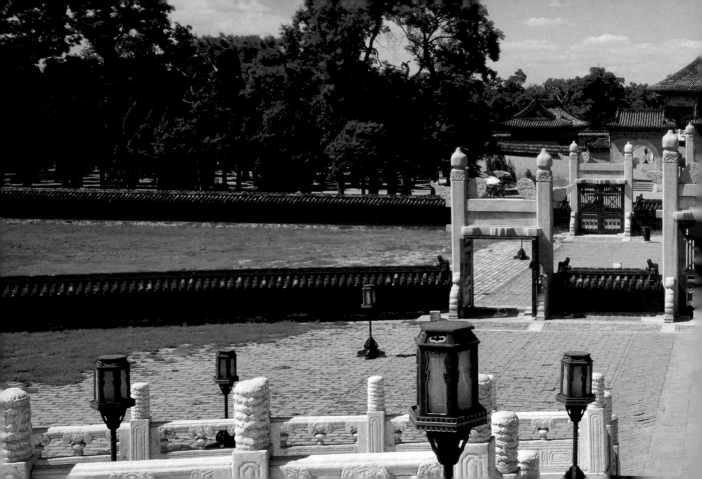

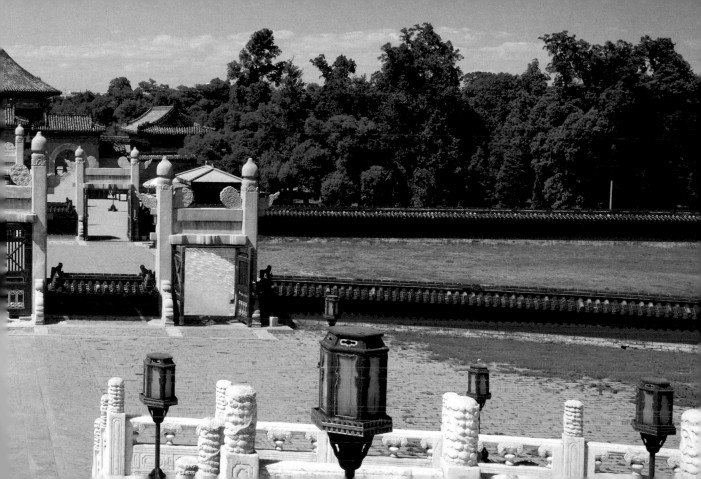

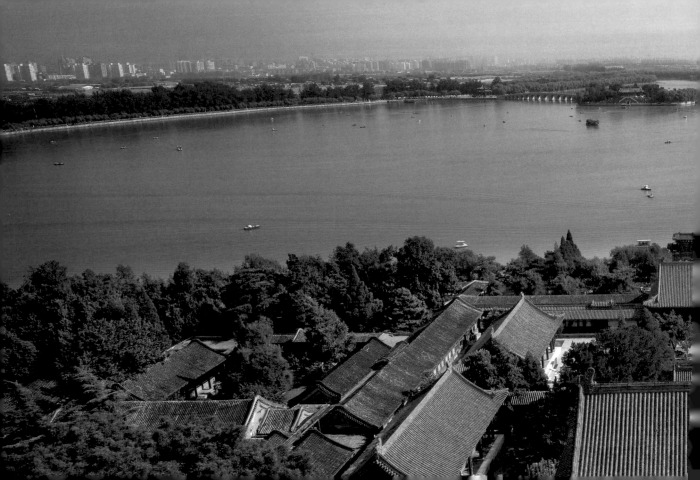

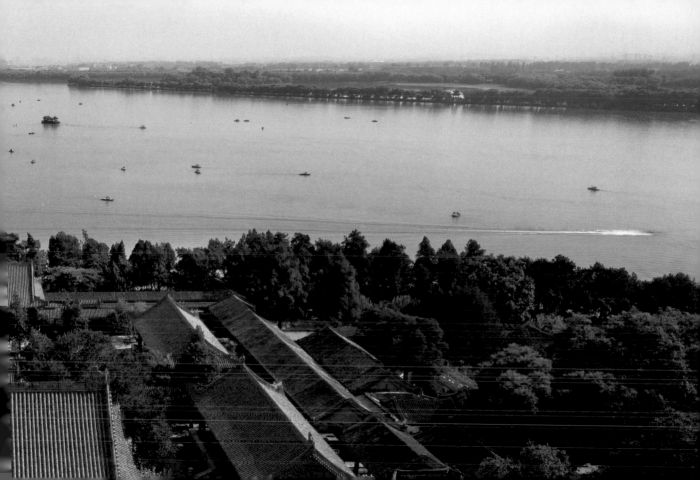

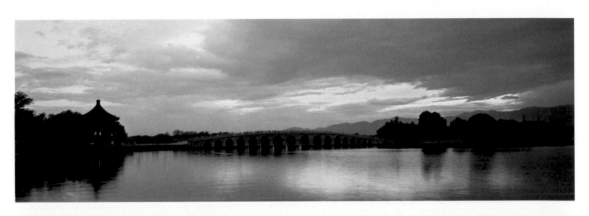

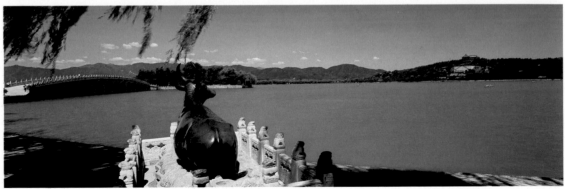

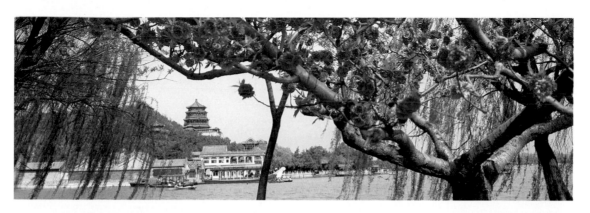

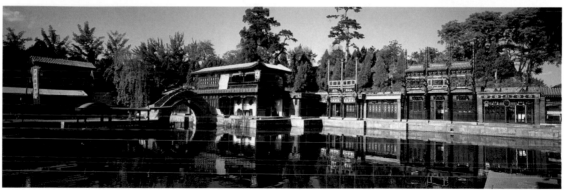

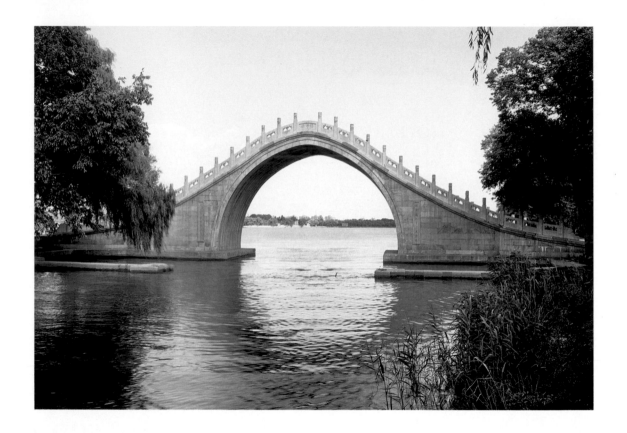

54

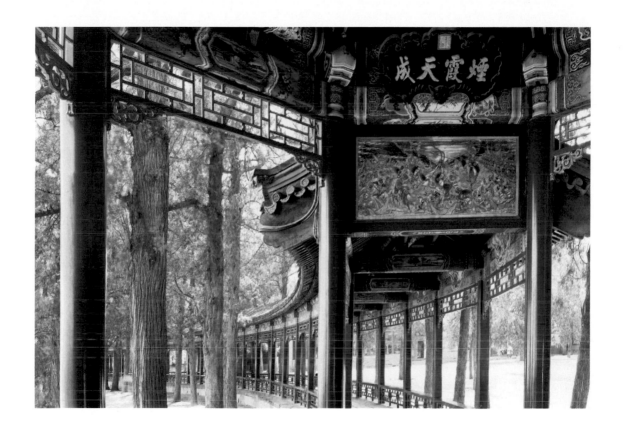

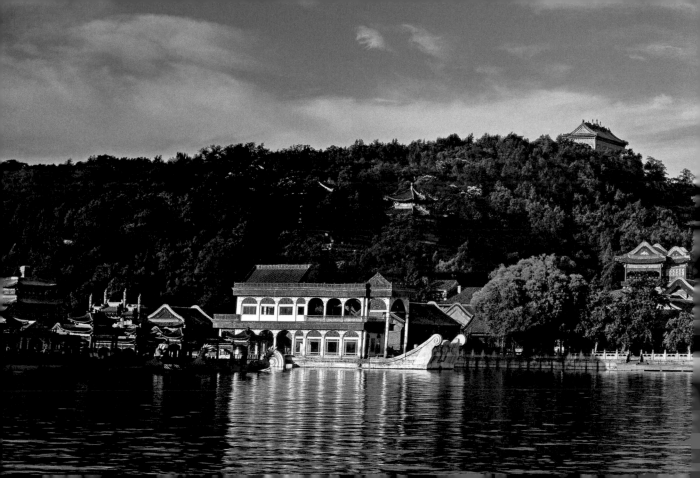

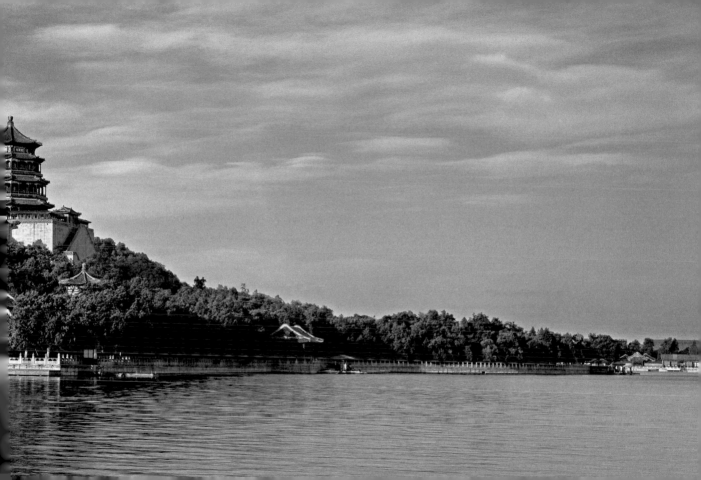

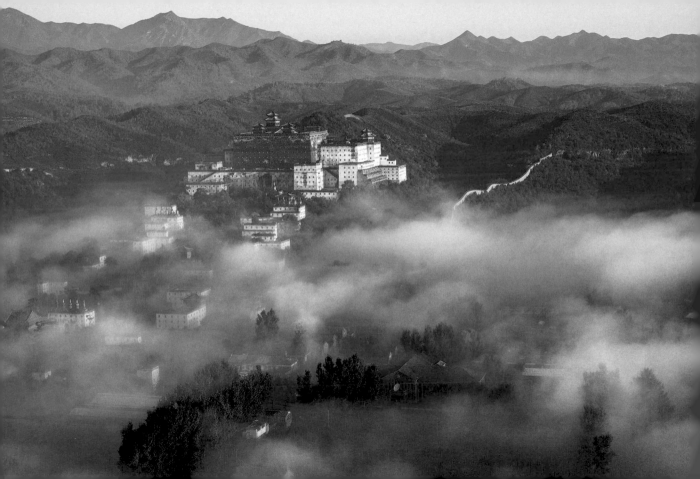

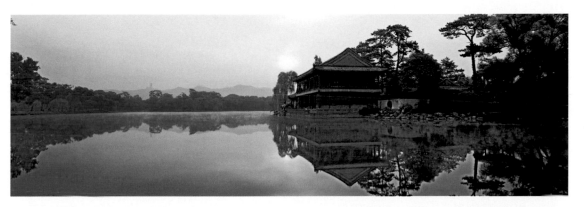

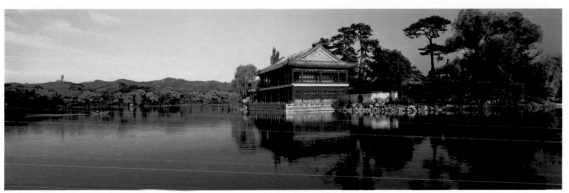

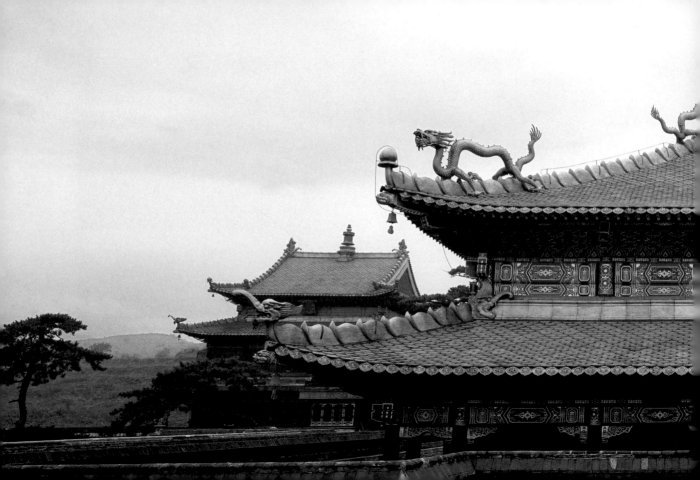

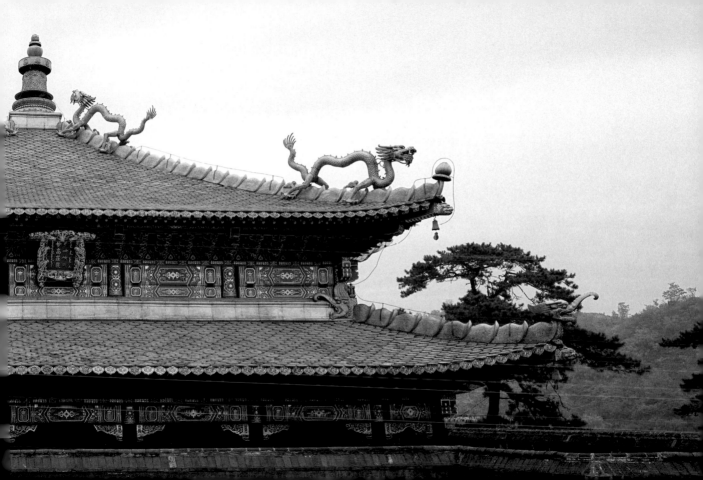

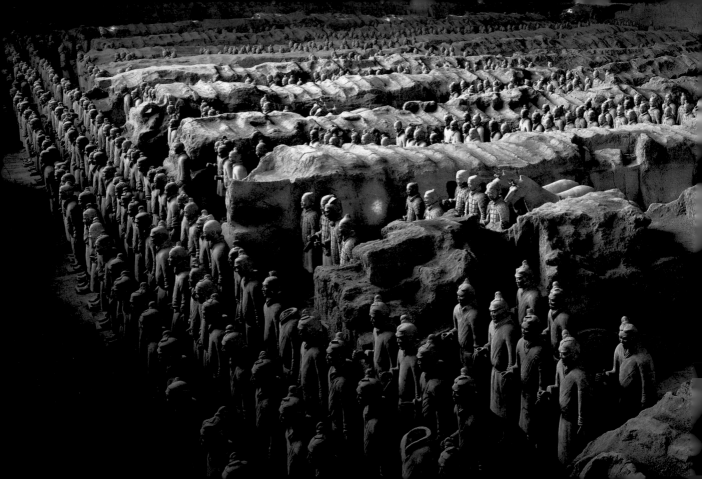

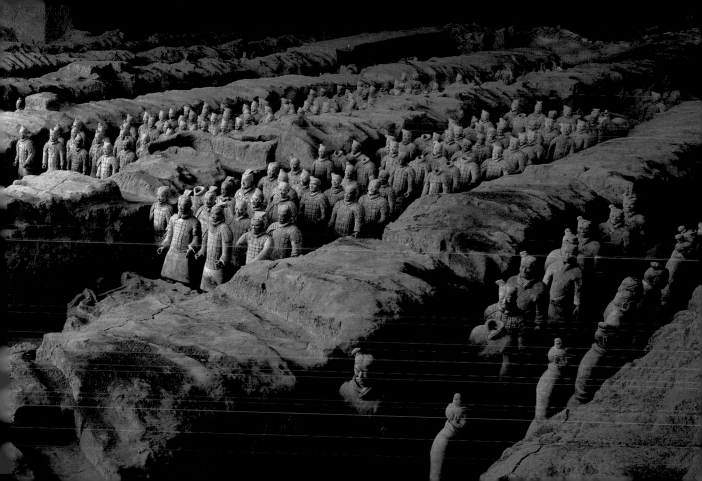

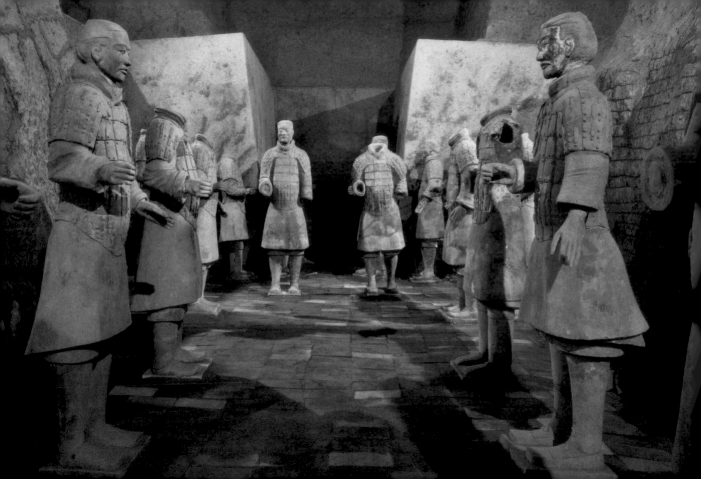

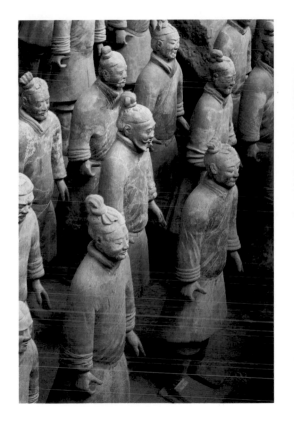
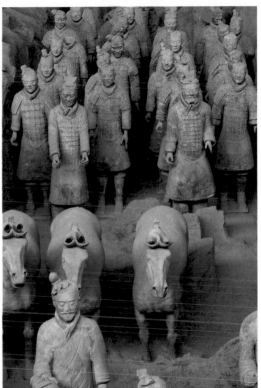
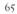

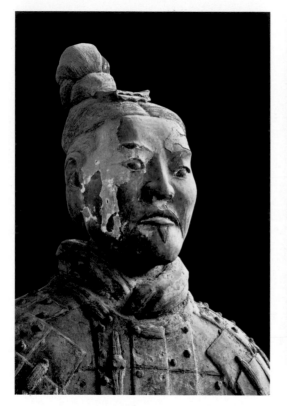

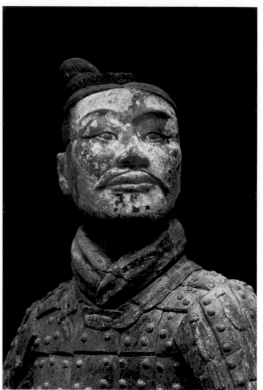

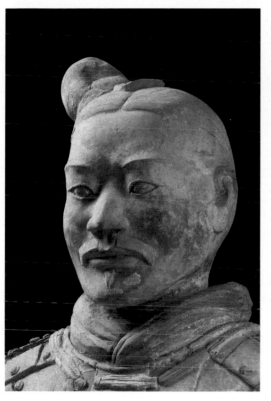
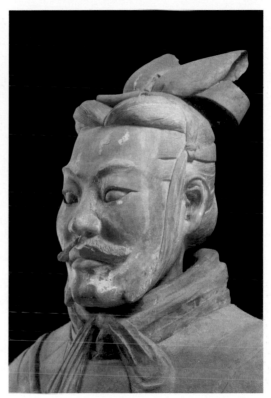

68

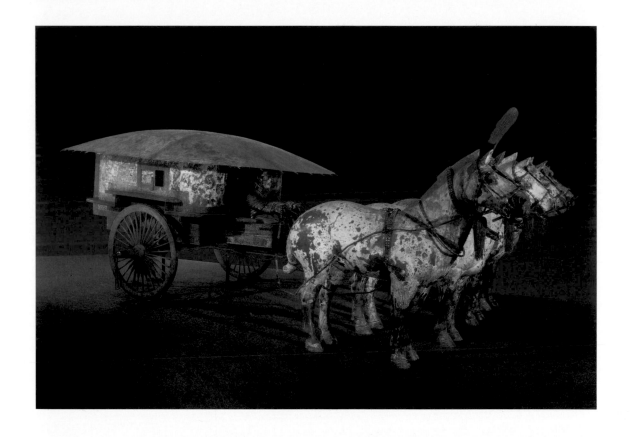

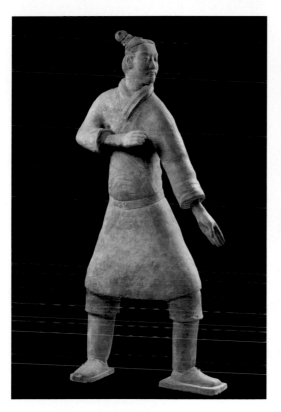
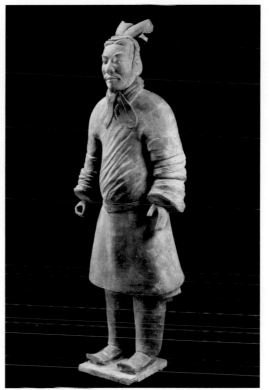

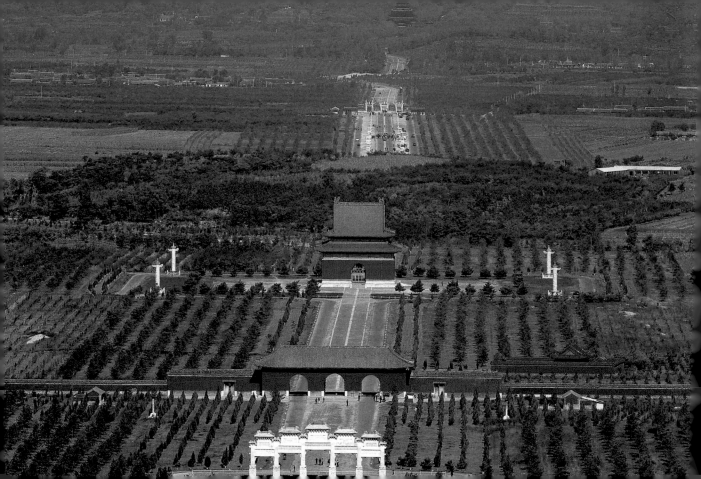

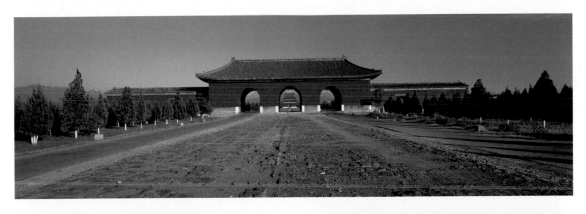

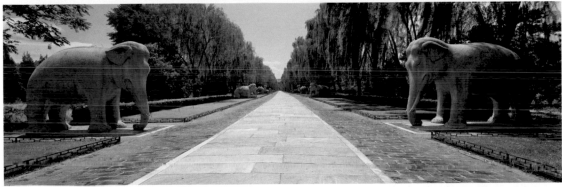

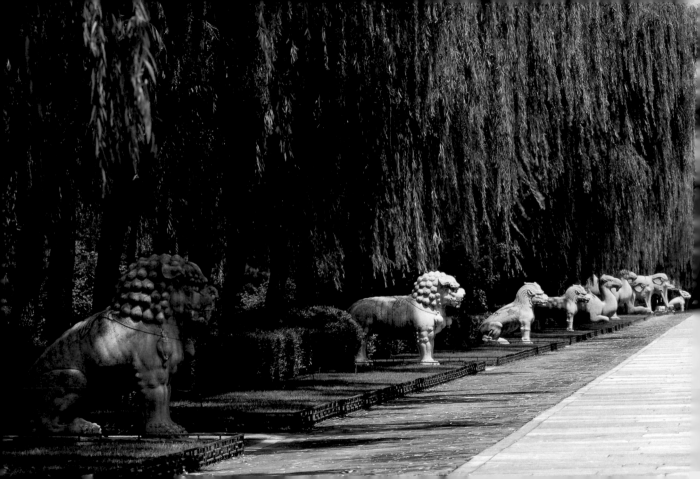

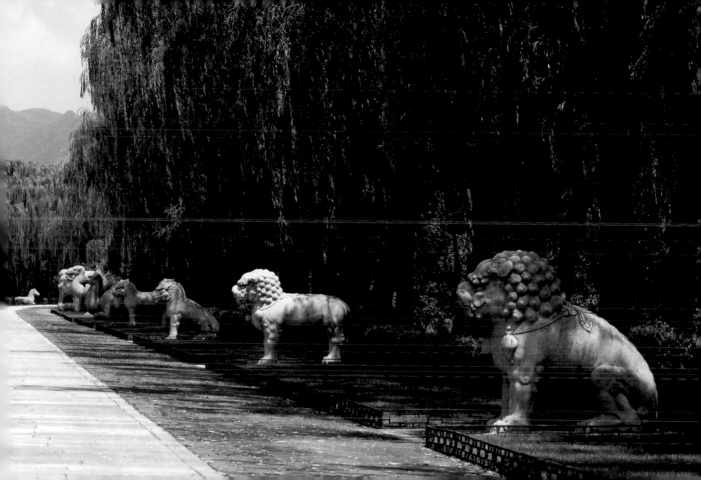

74

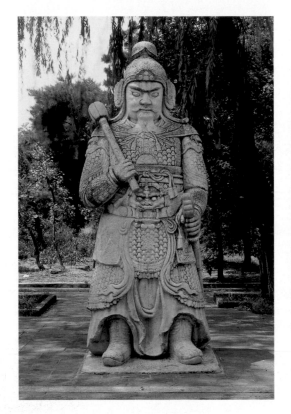
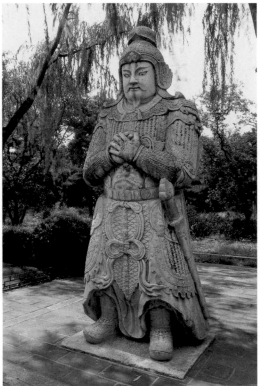

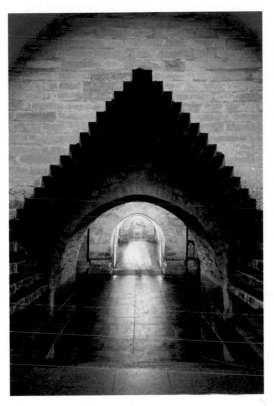

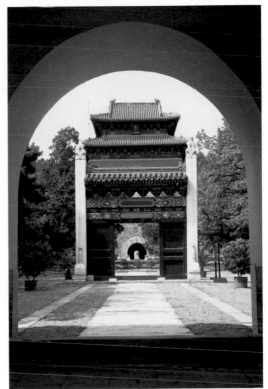

78

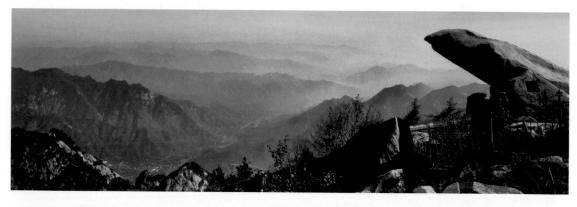

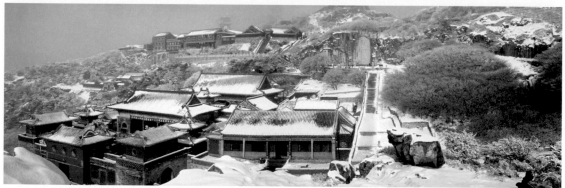

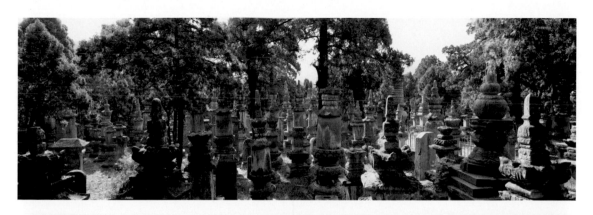

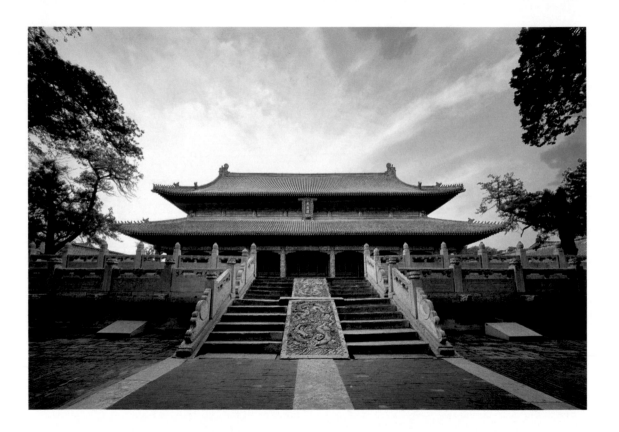

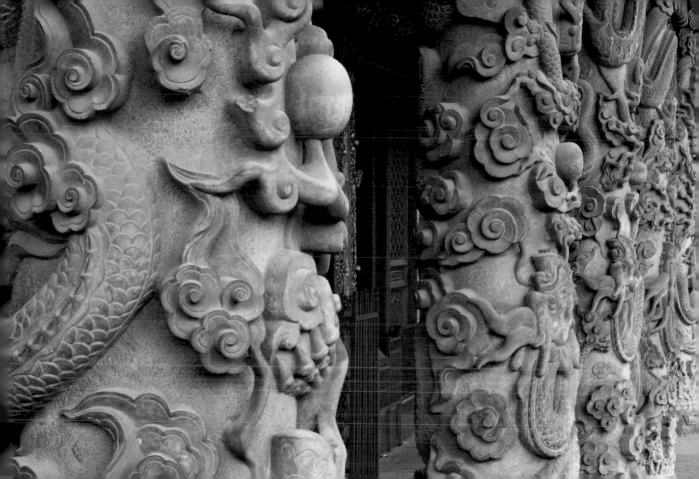

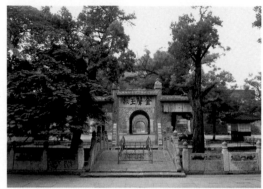

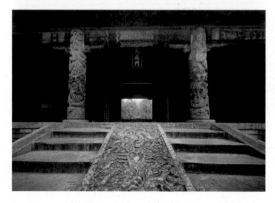

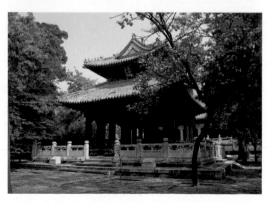

88

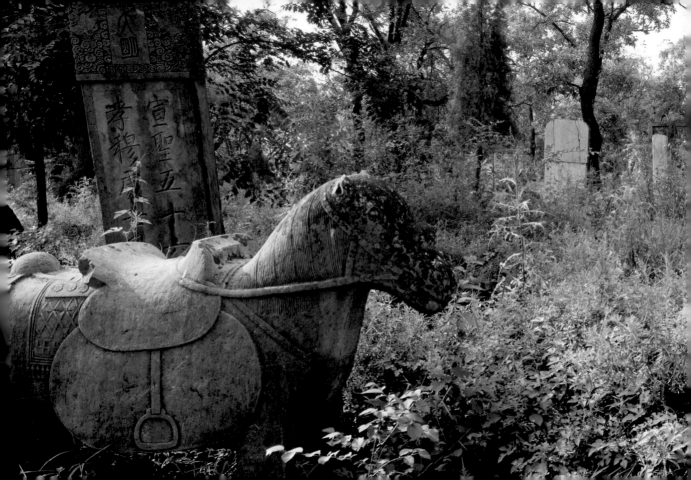

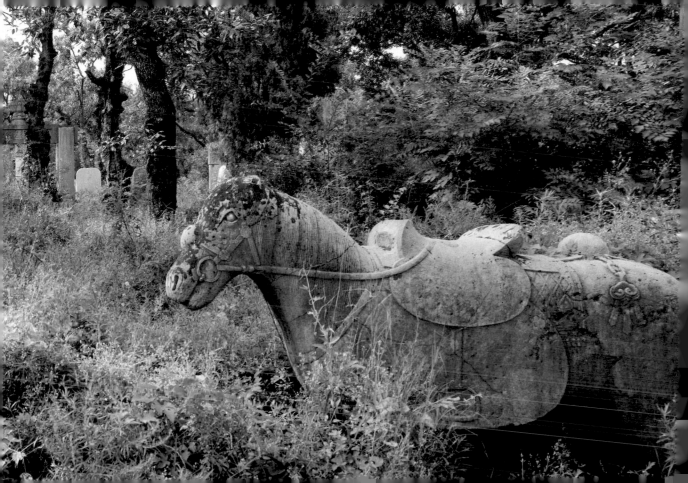

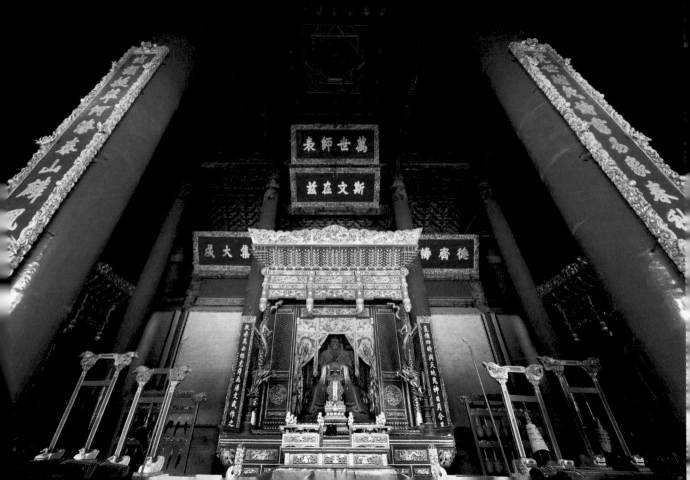

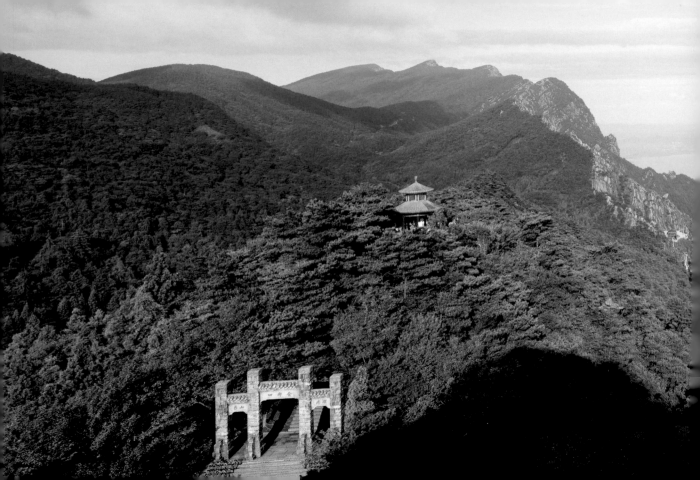

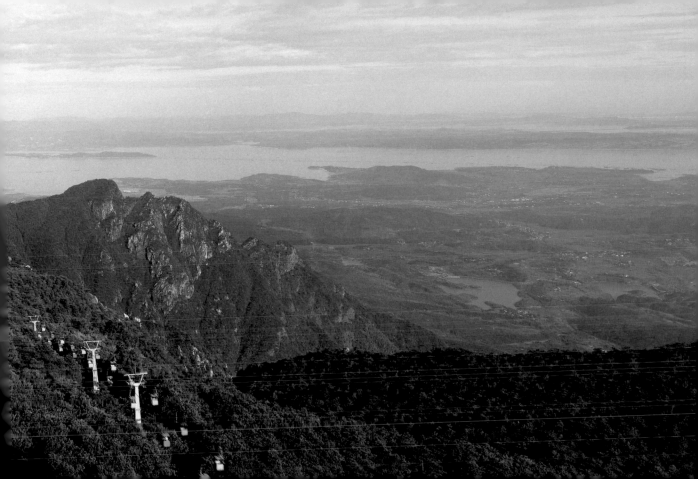

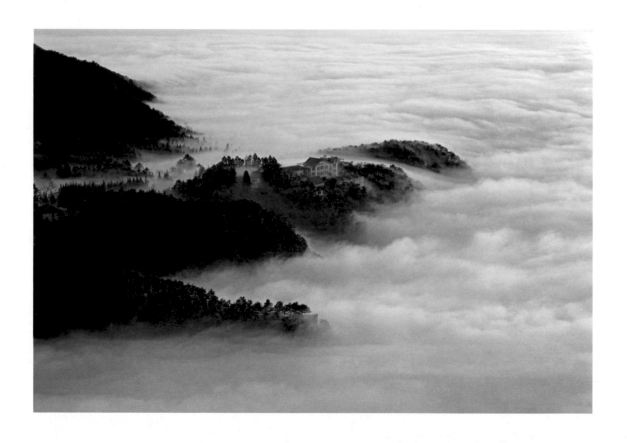

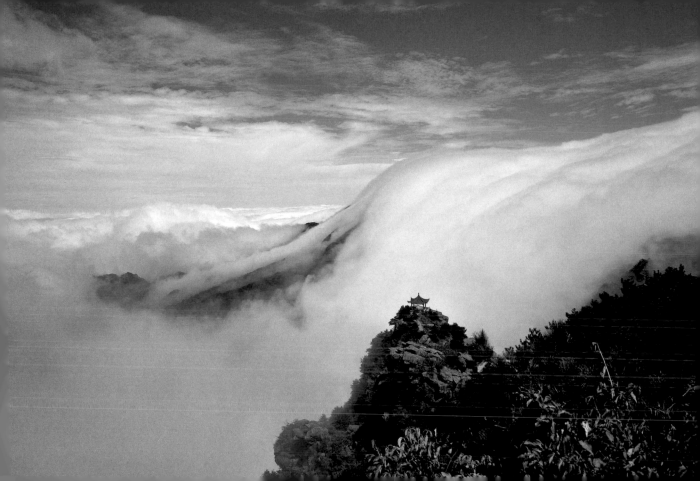

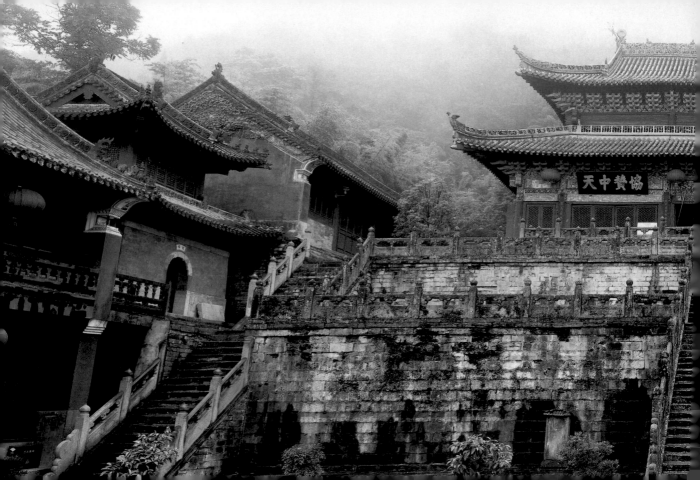

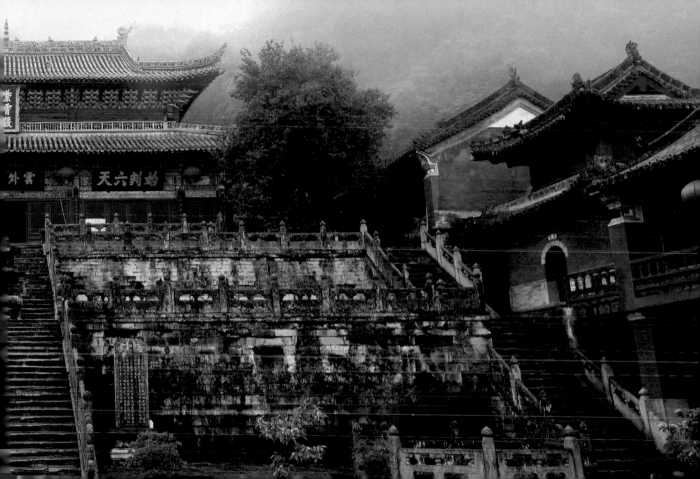

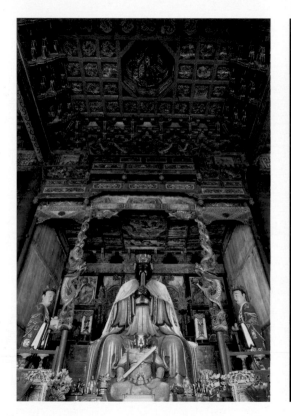

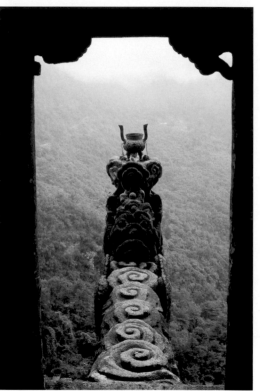

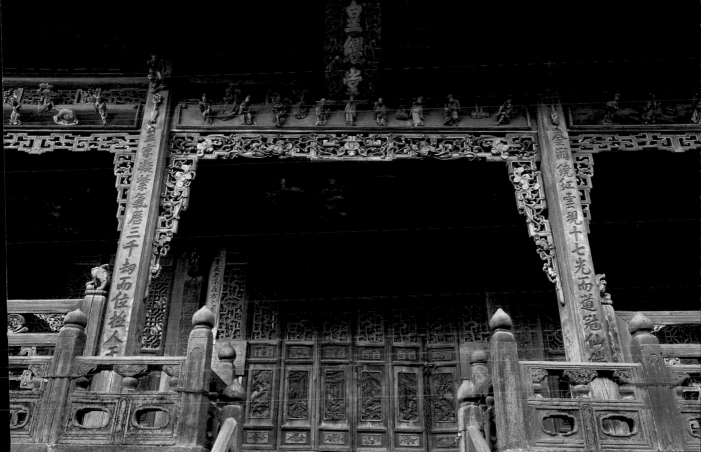

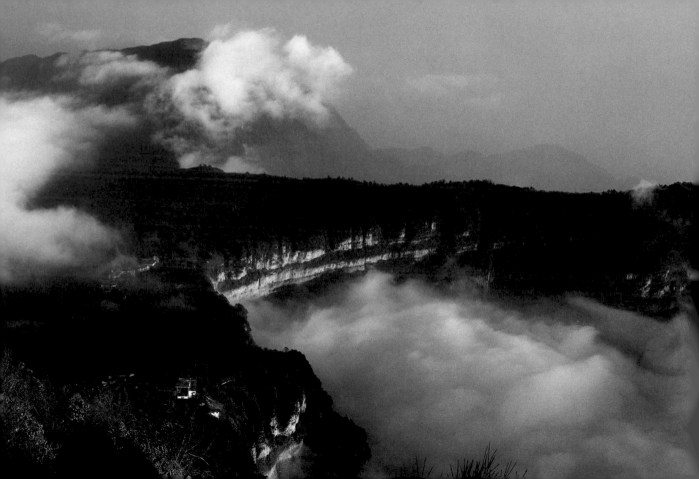

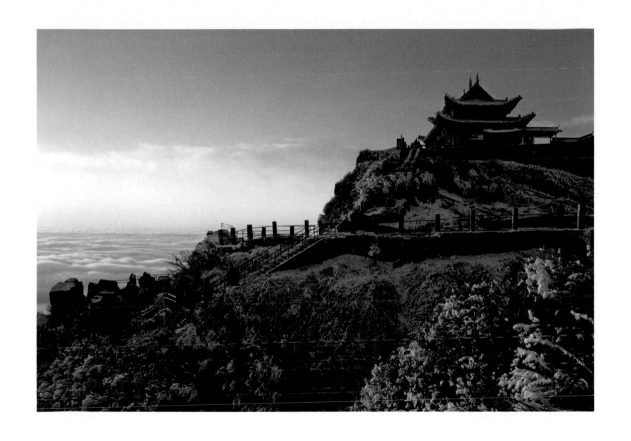

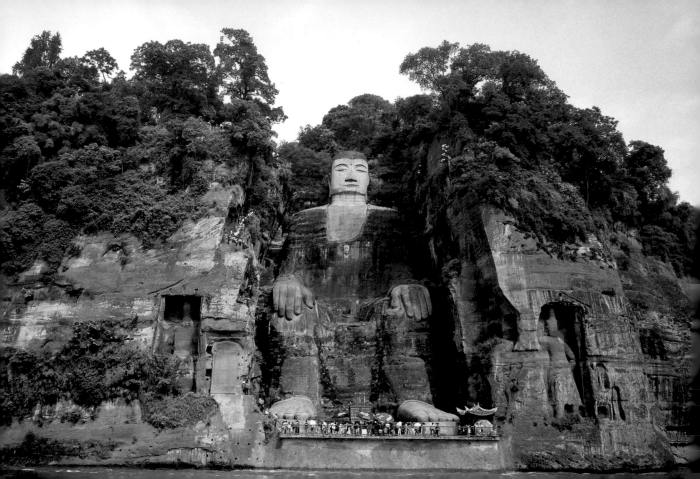

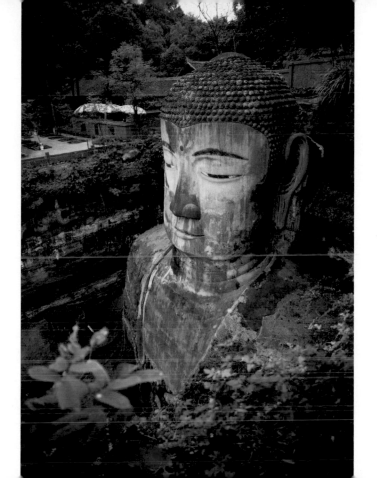

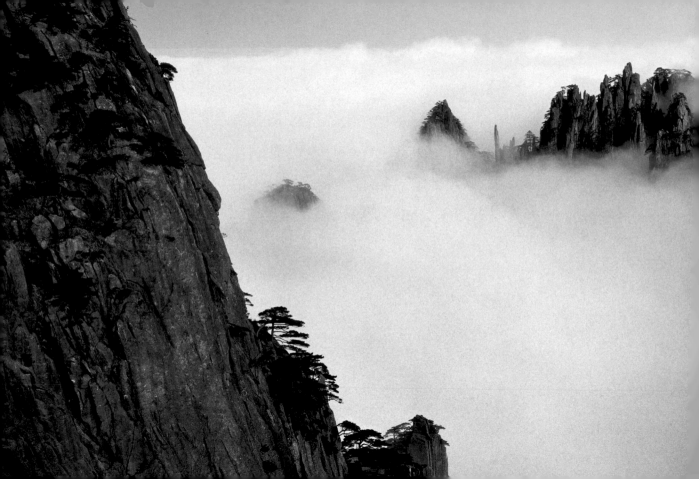

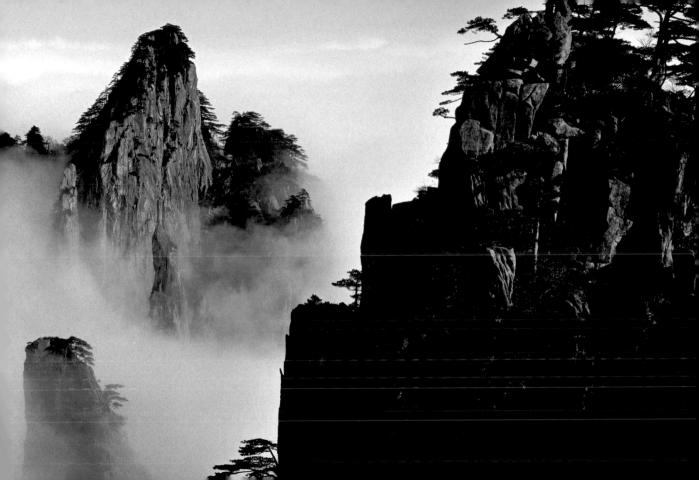

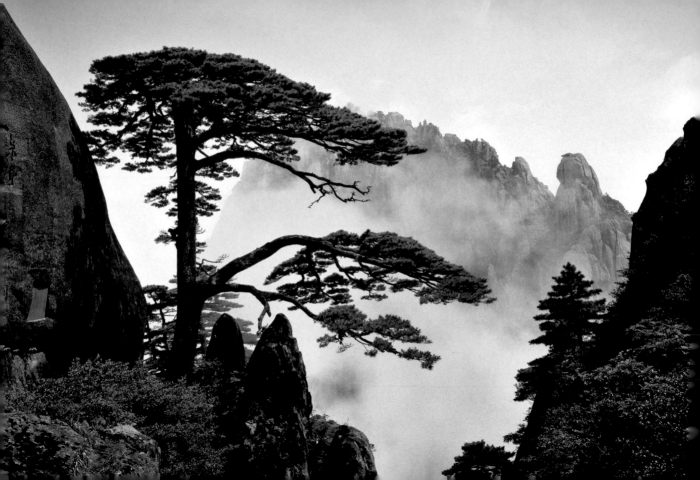

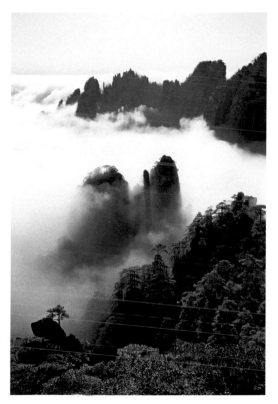

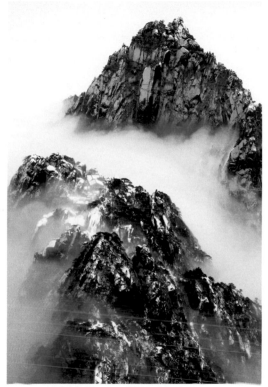

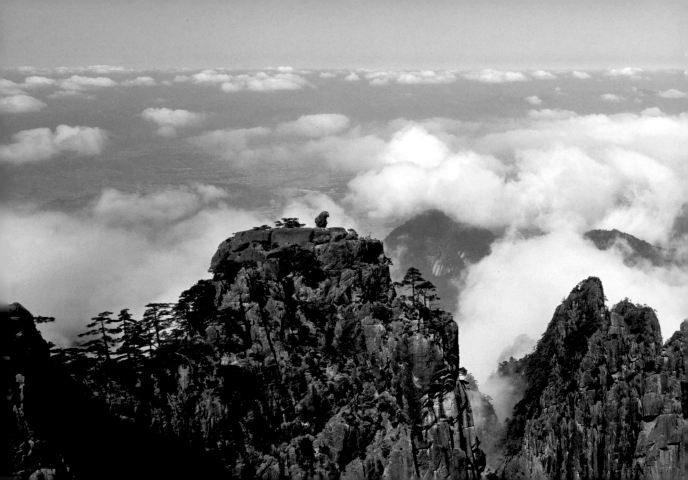

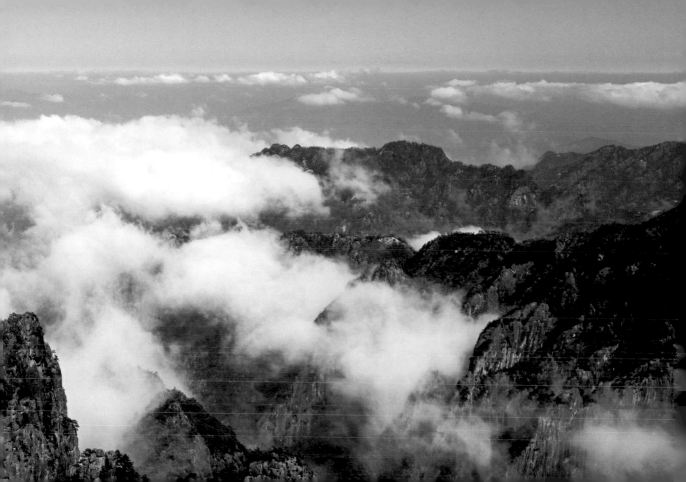

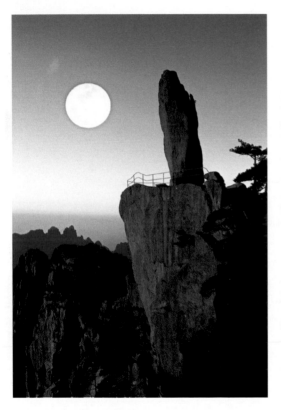
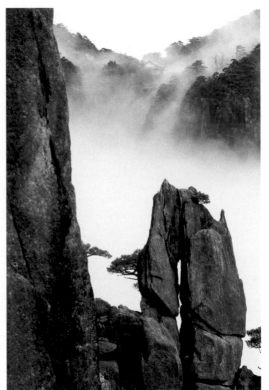

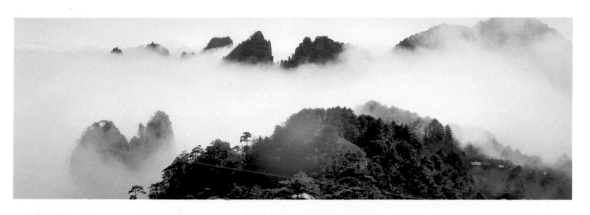

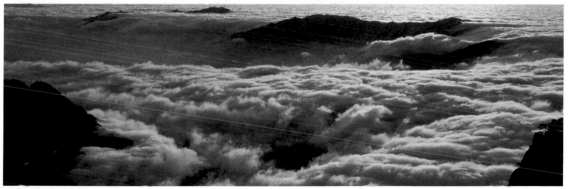

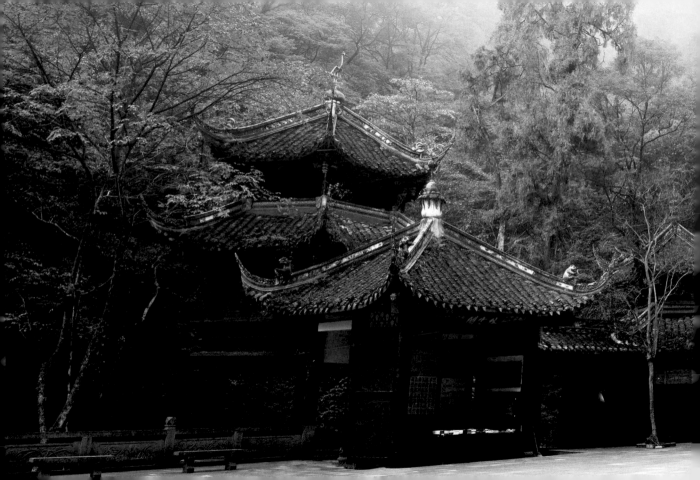

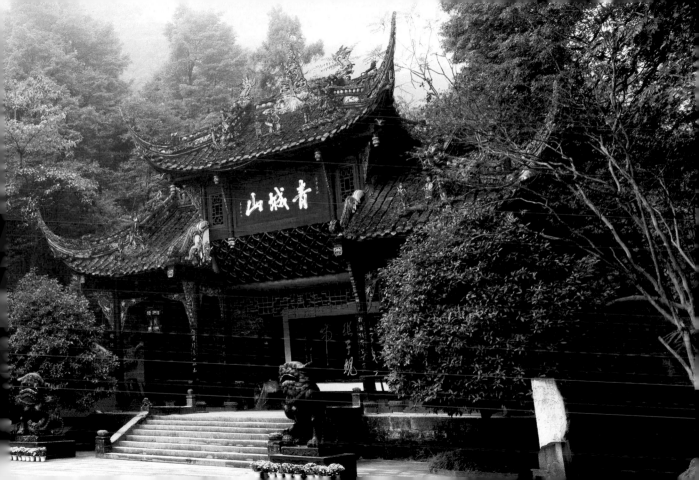

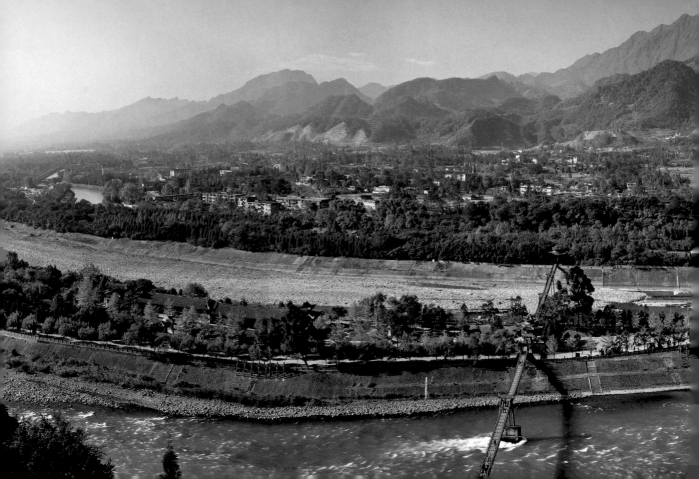

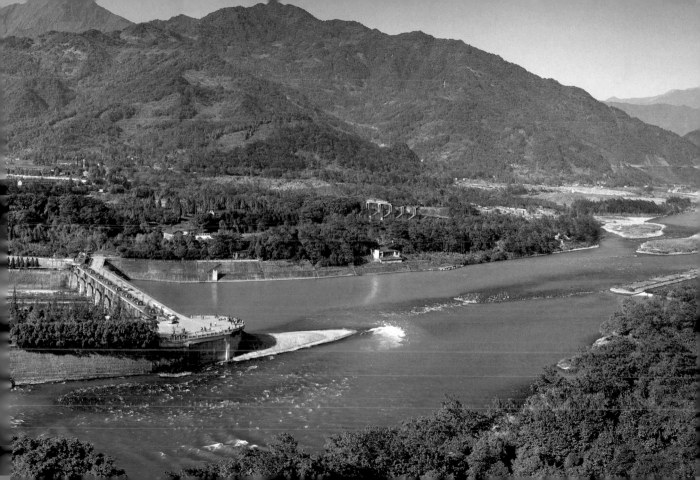

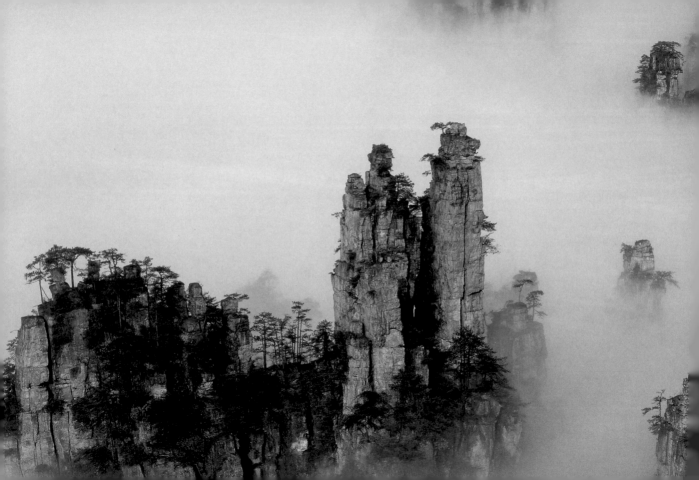

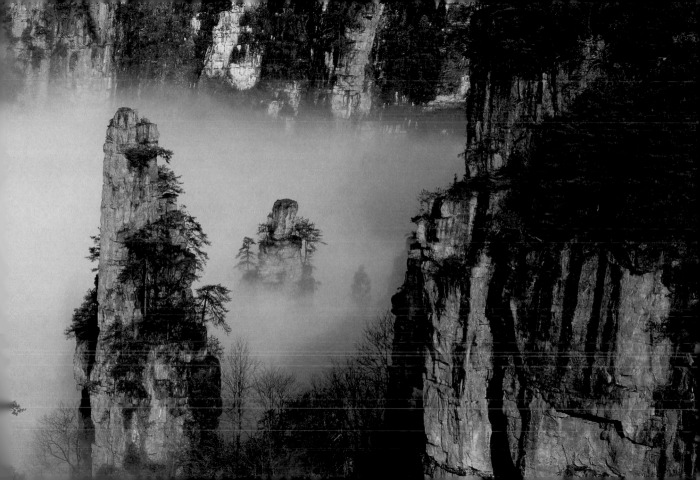

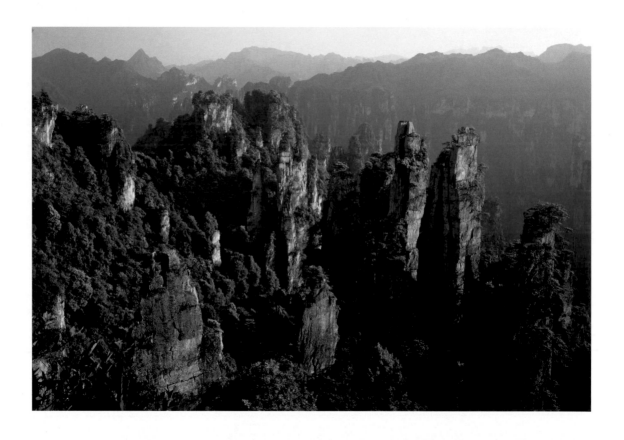

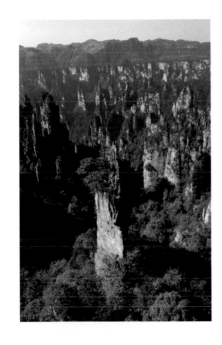

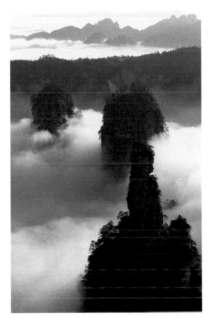

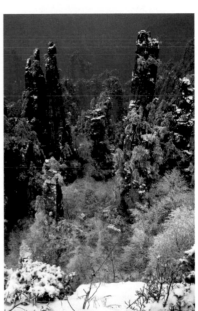

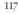

117

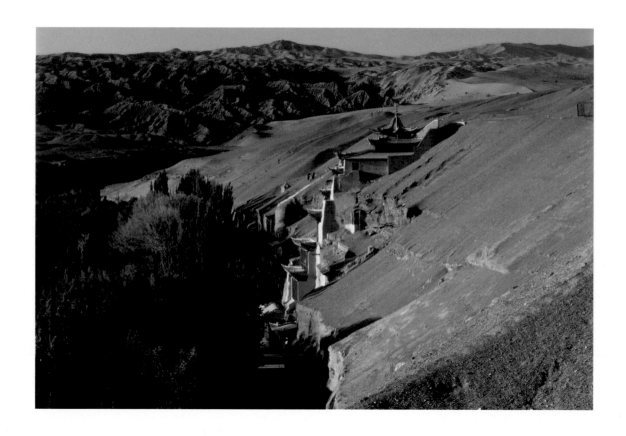

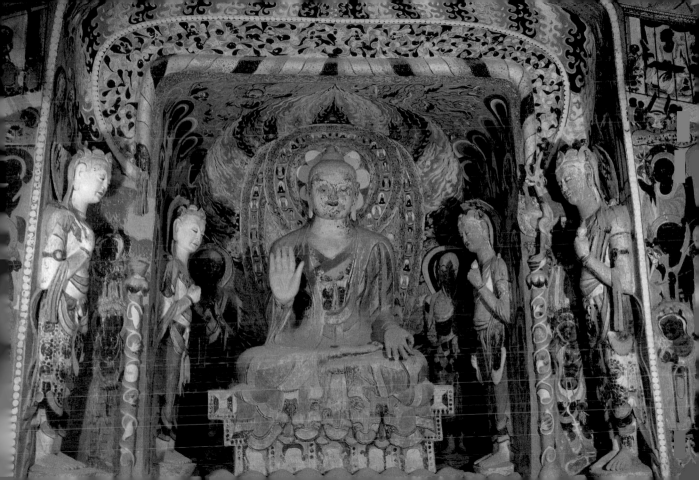

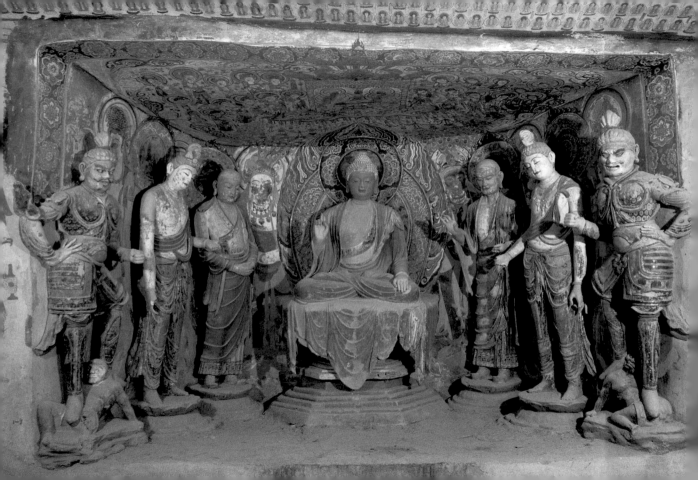

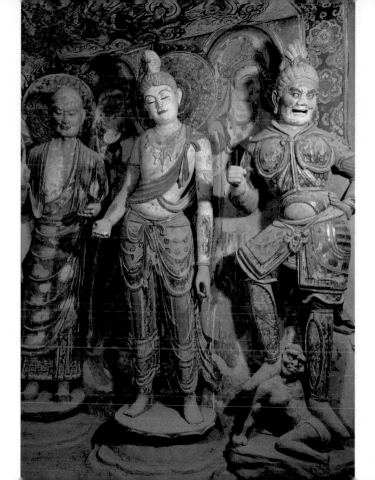

121

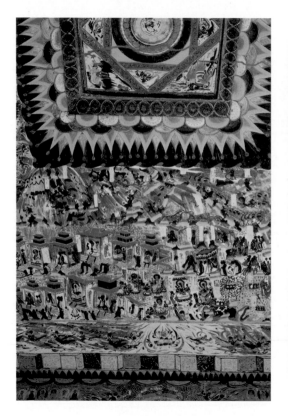

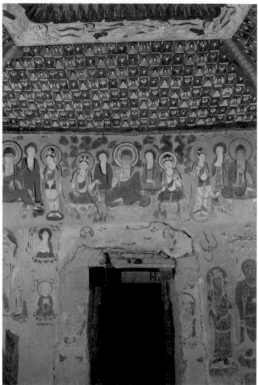

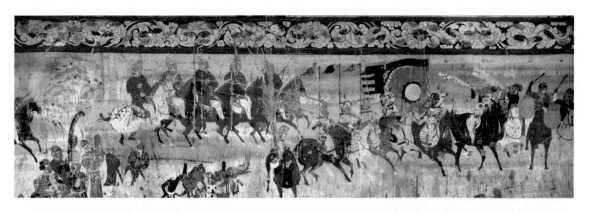

123

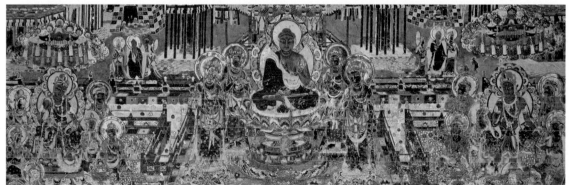

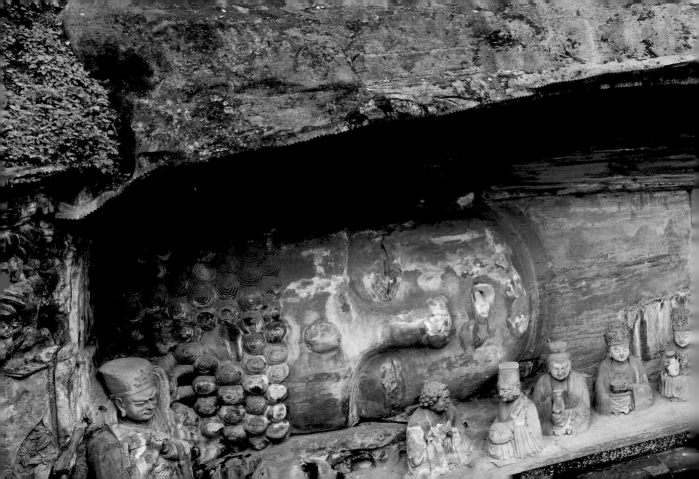

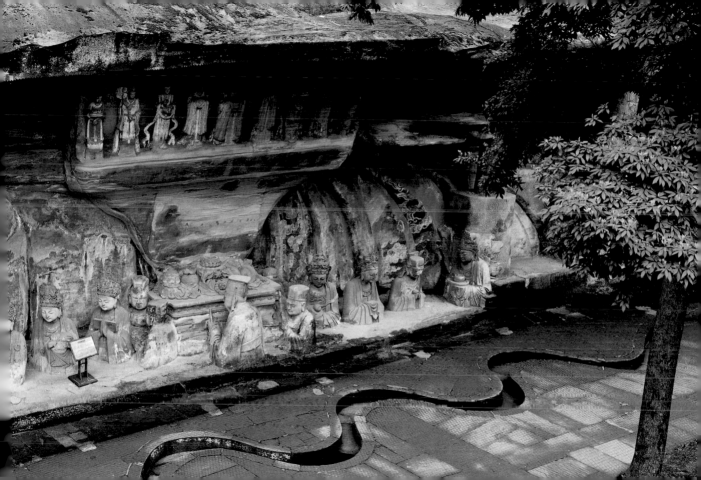

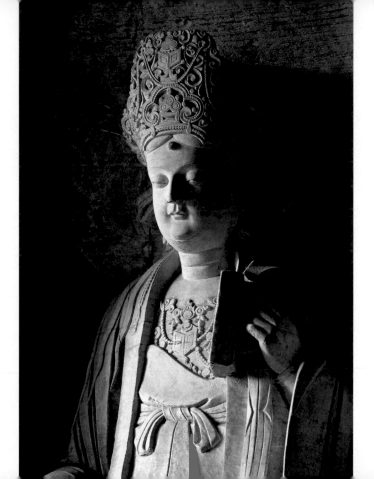

126

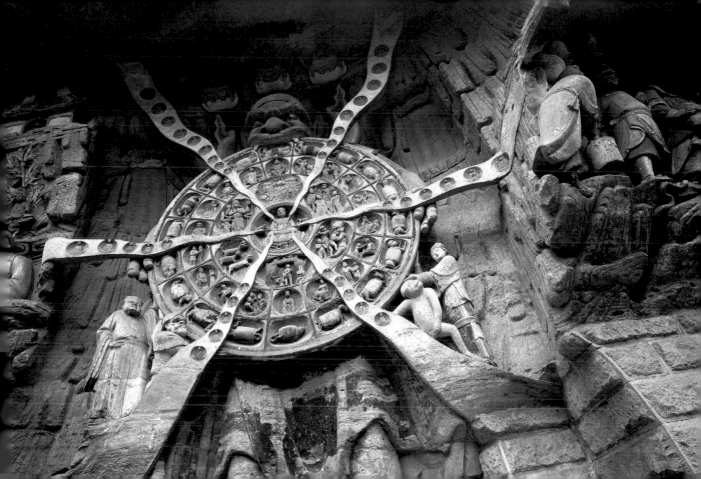

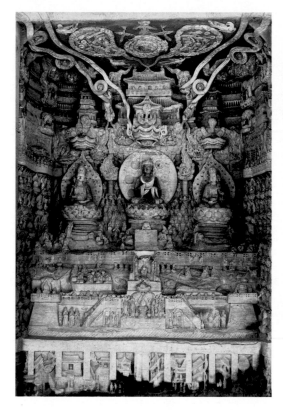

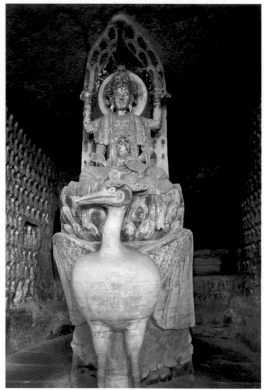

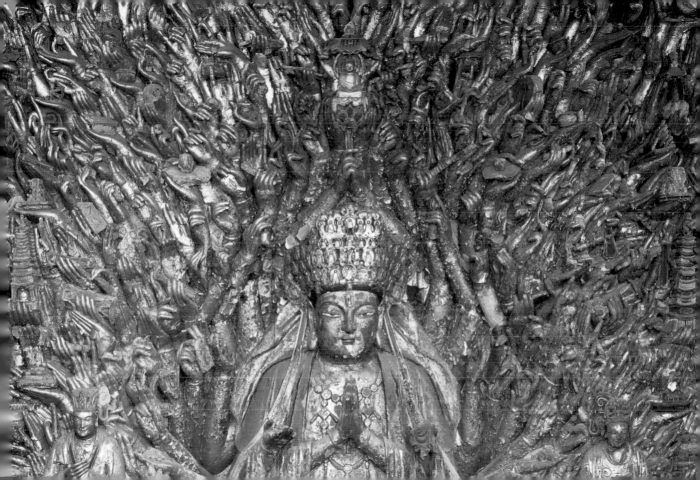

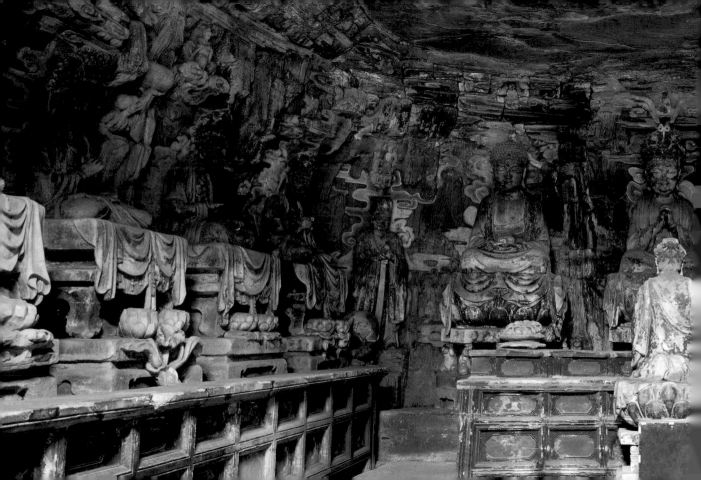

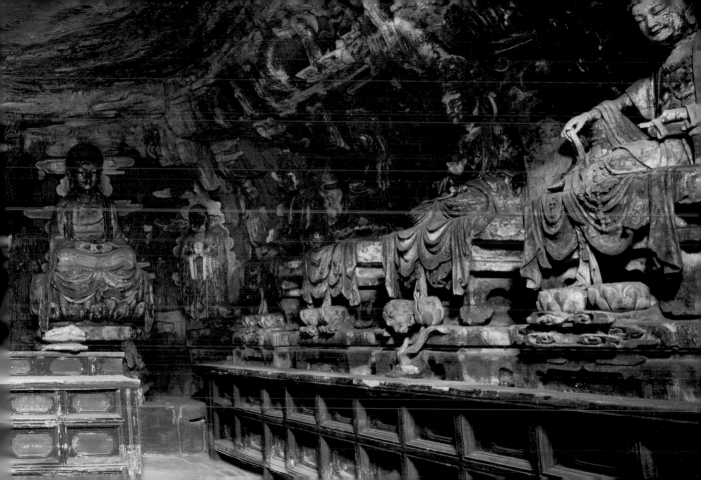

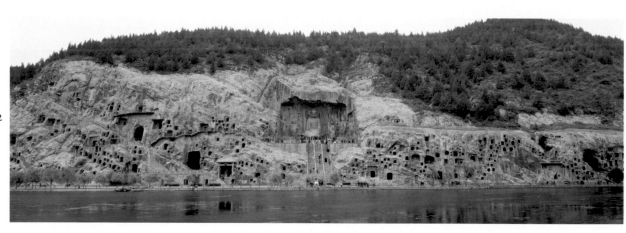

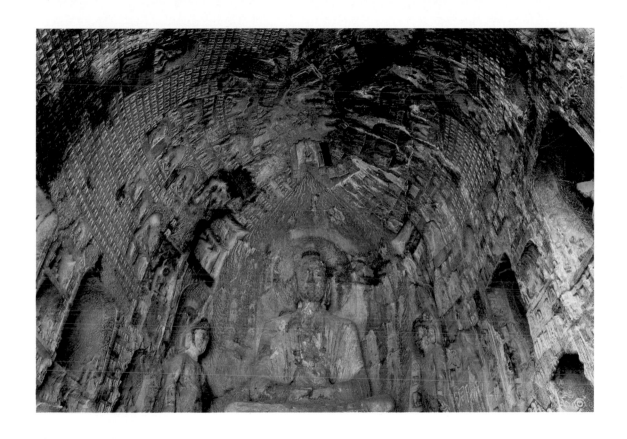

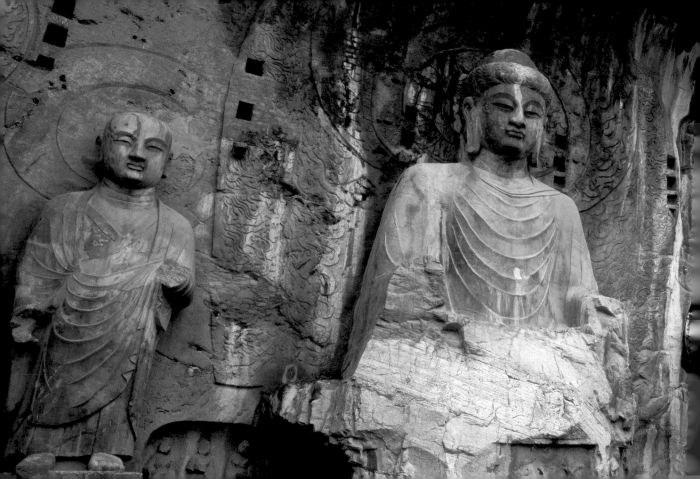

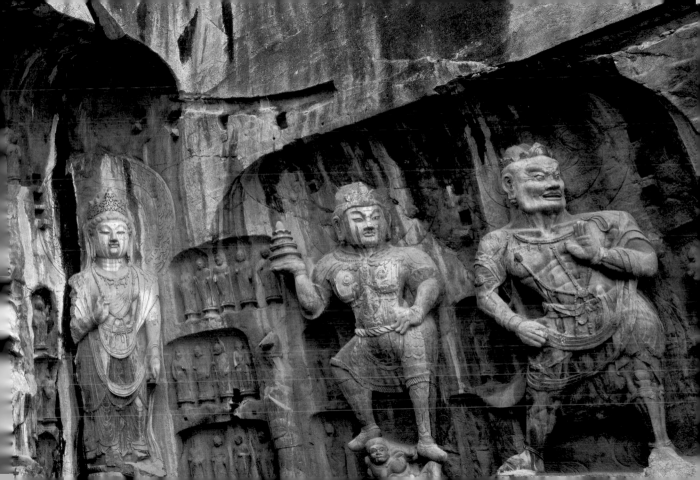

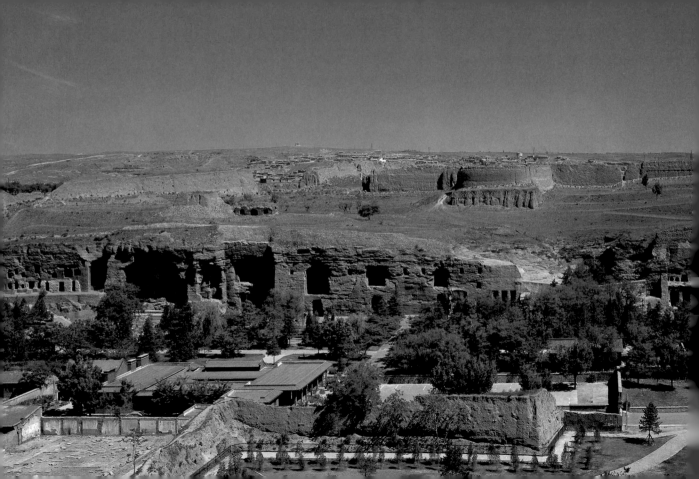

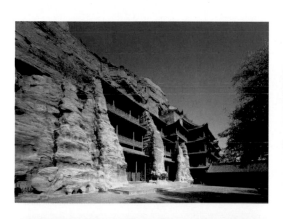

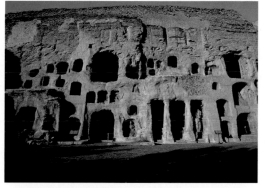

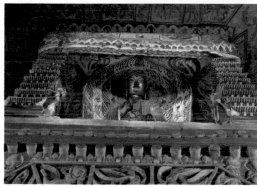

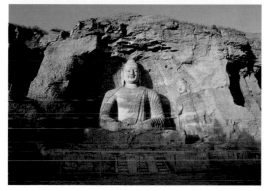

138

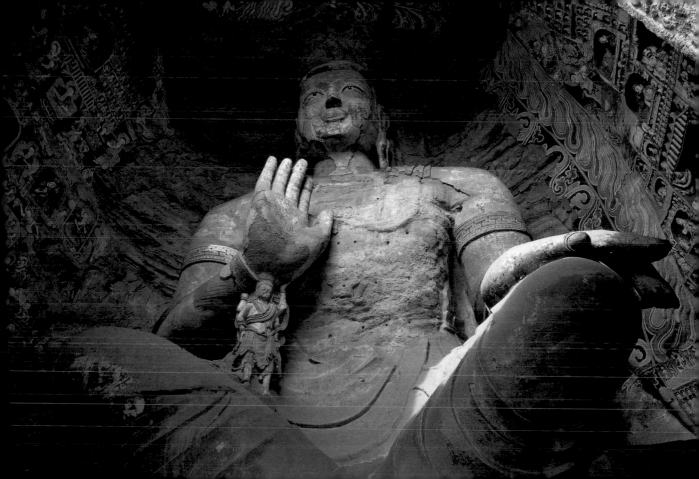

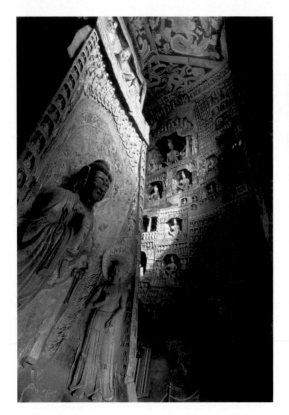

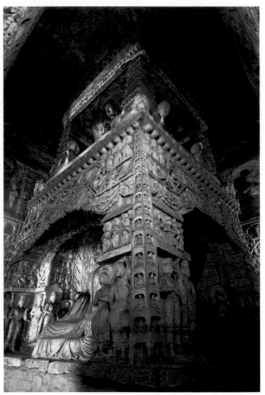

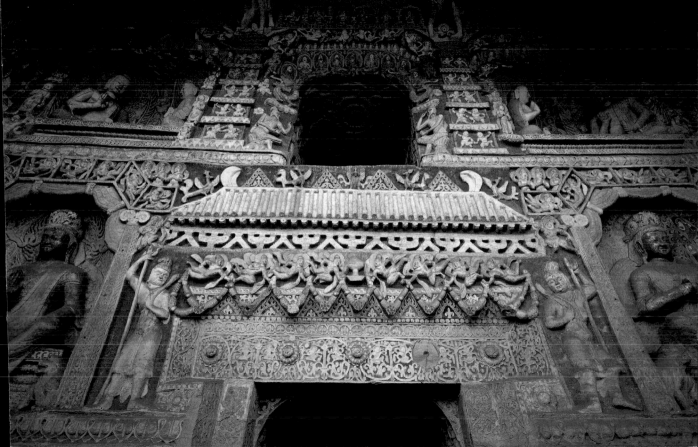

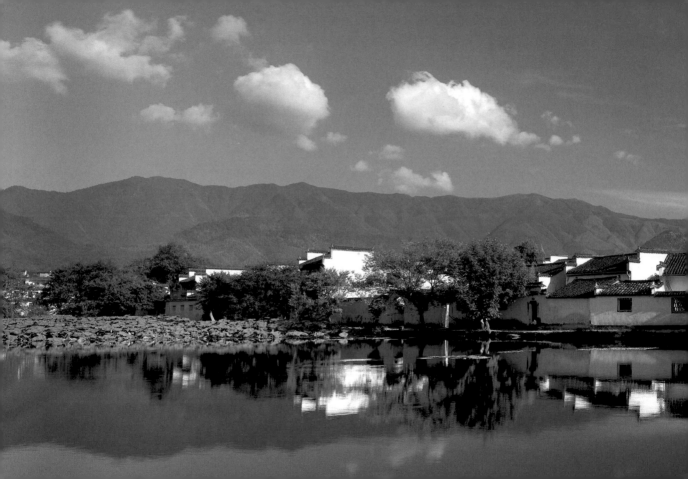

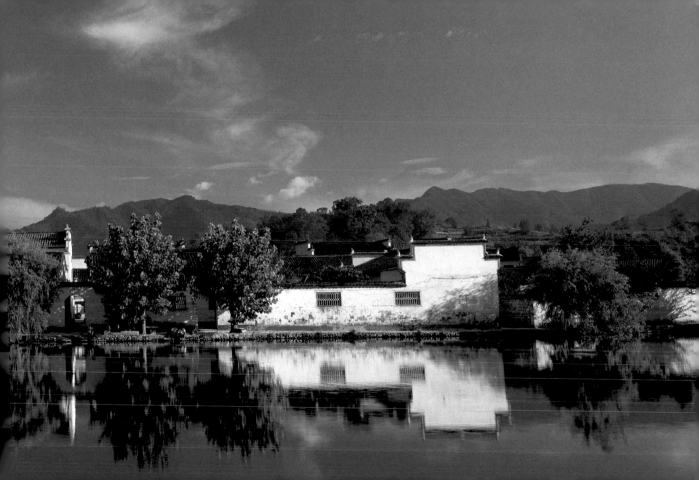

144

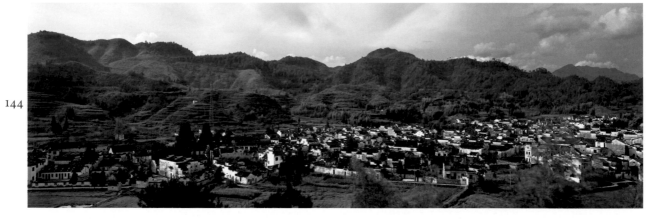

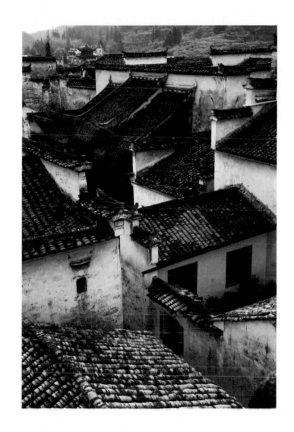

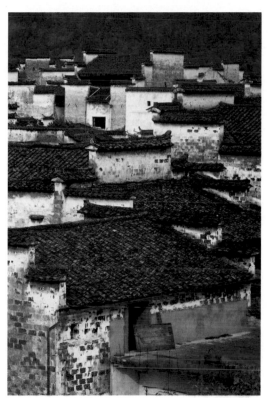

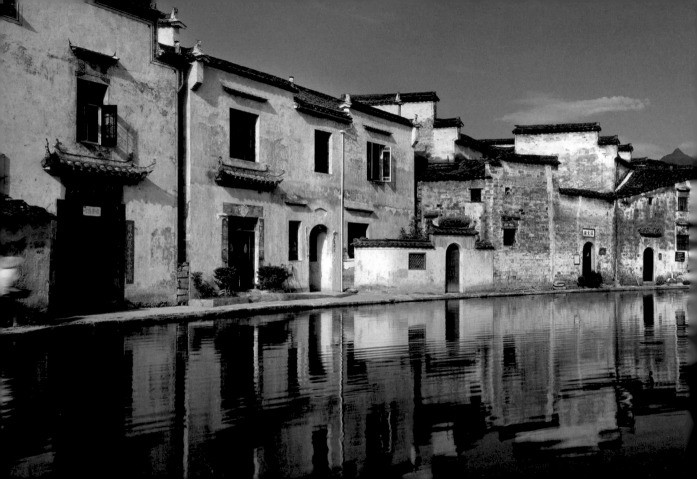

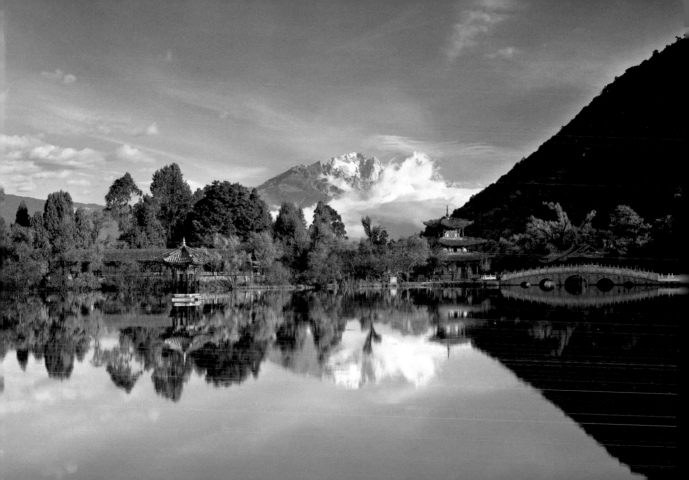

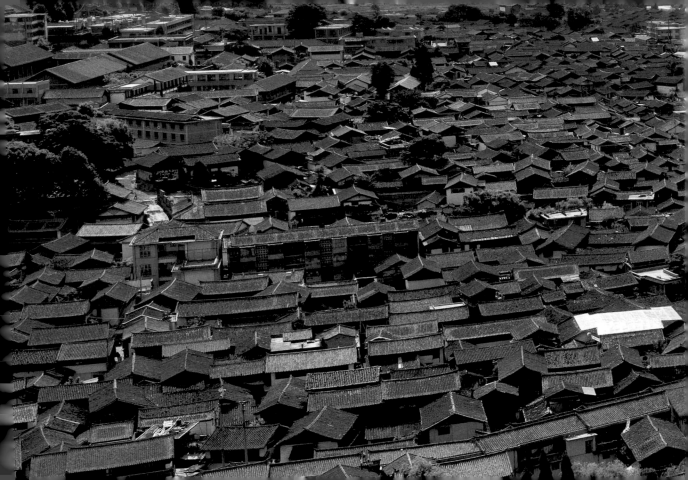

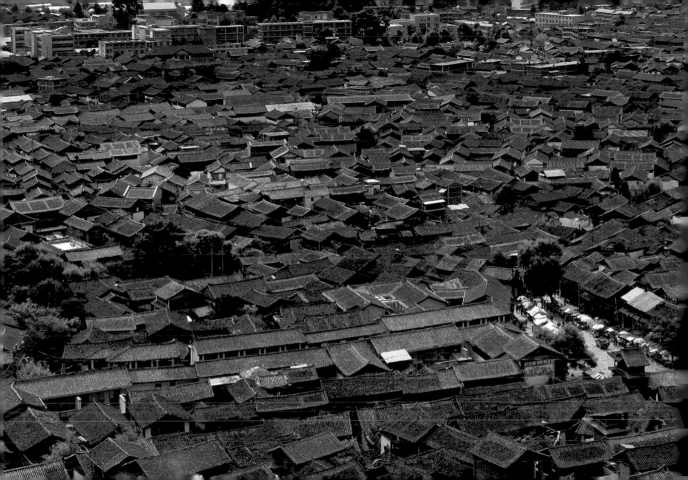

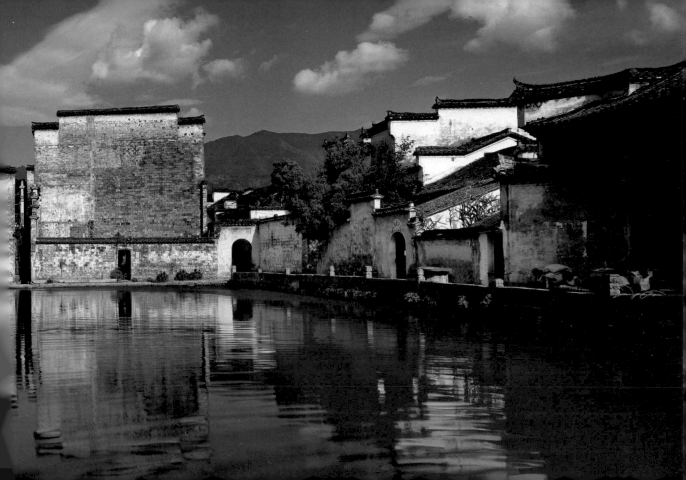

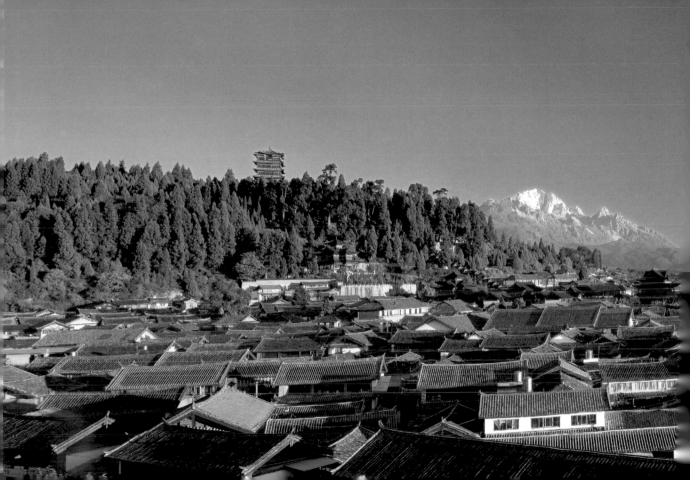

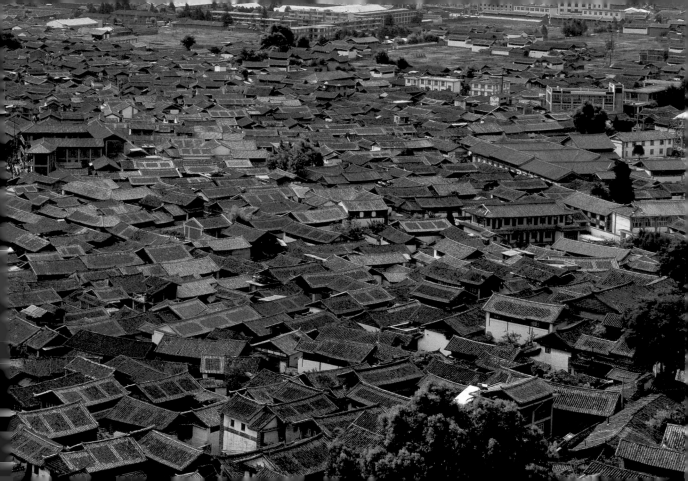

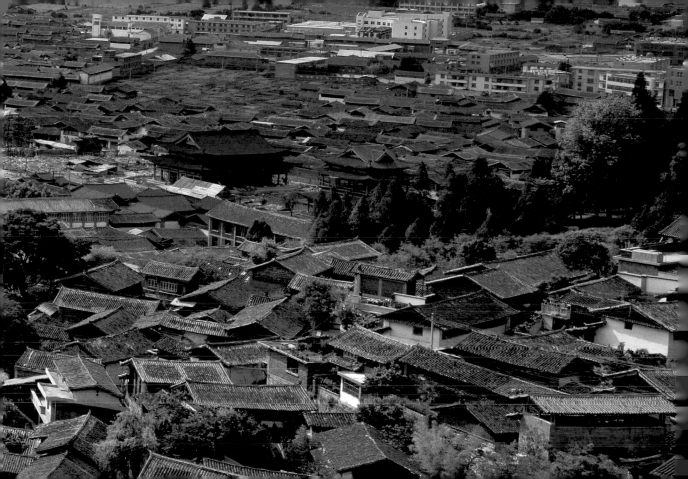

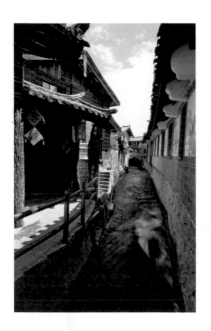
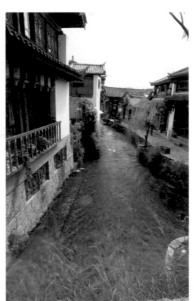
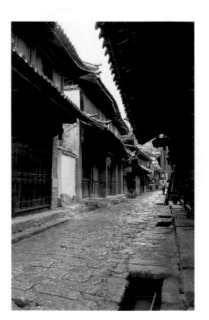

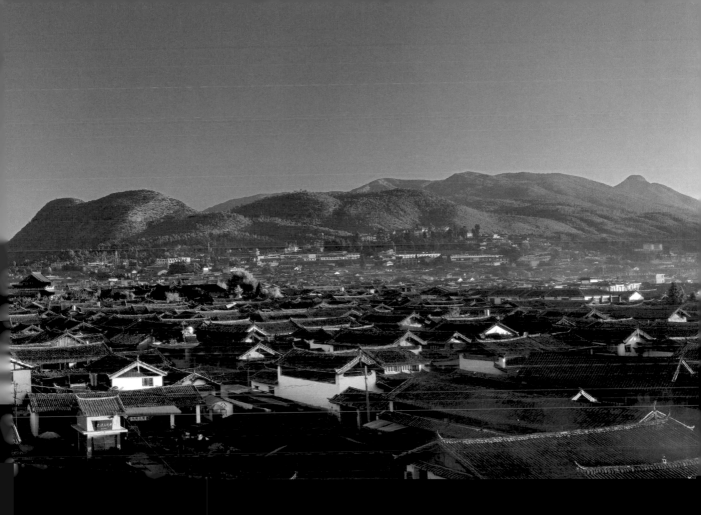

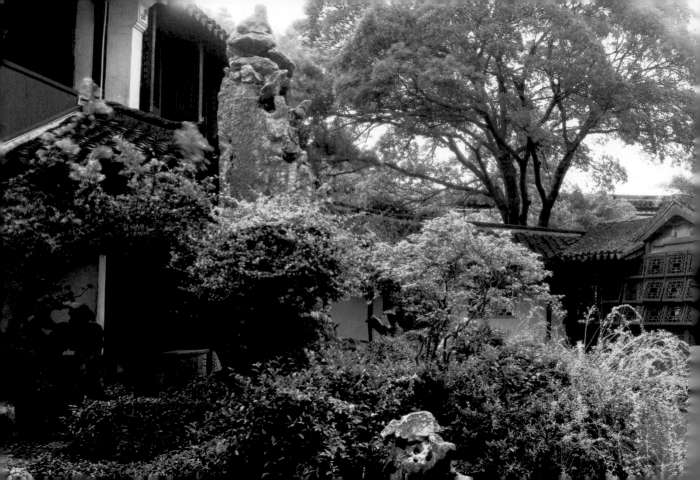

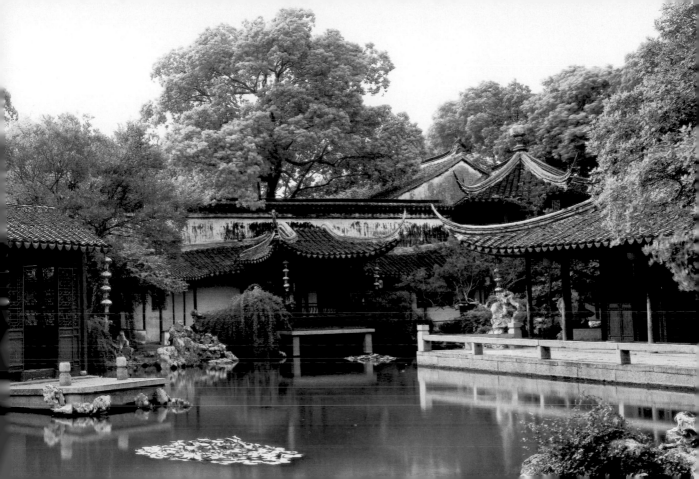

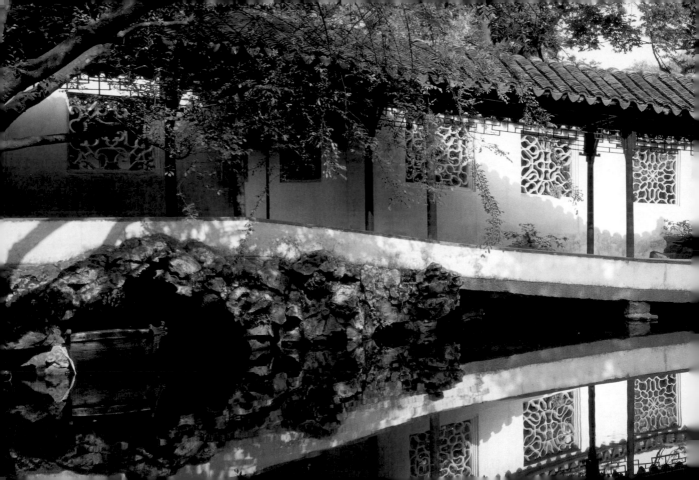

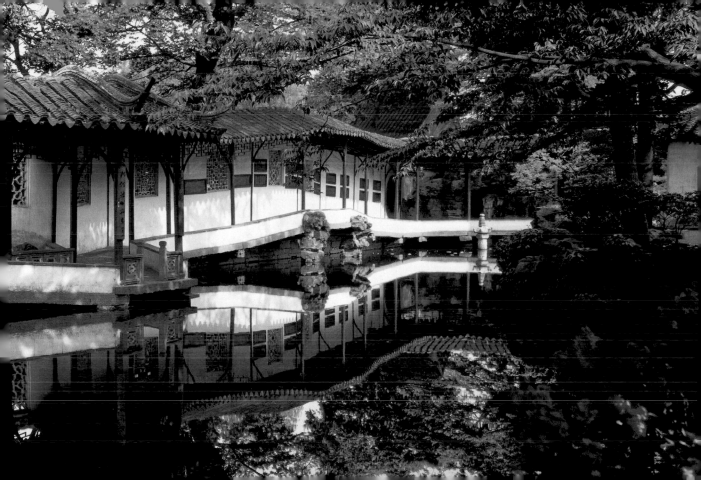

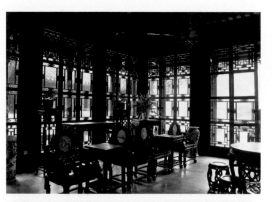

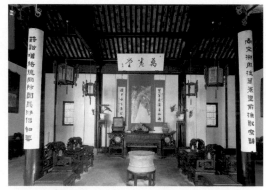

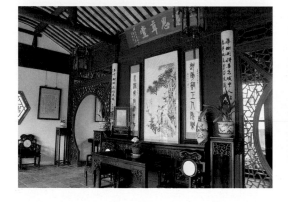

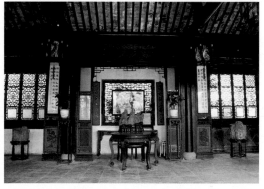

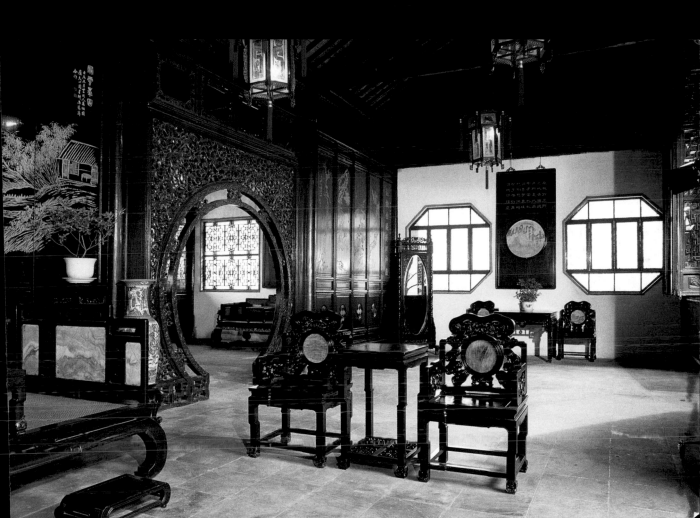

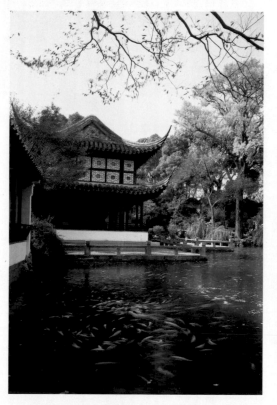

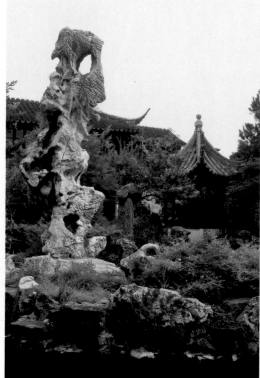

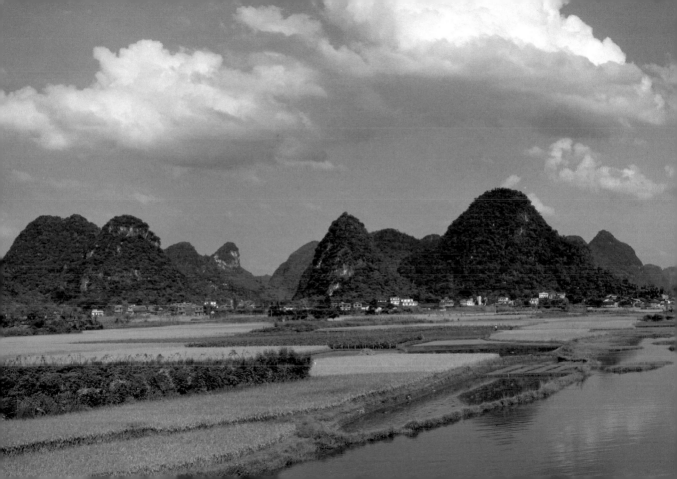

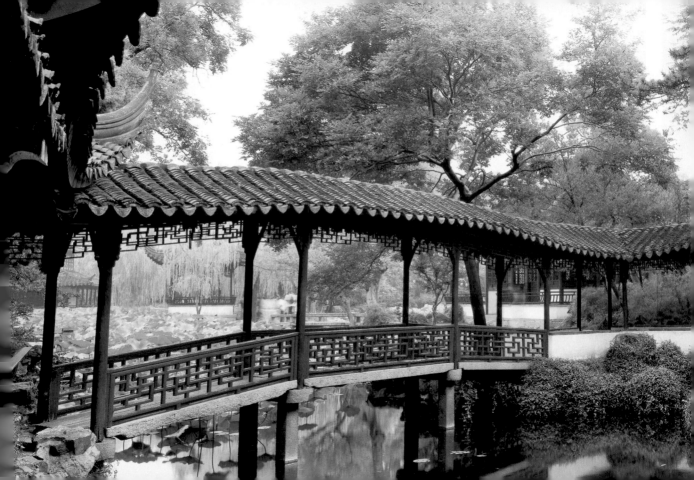

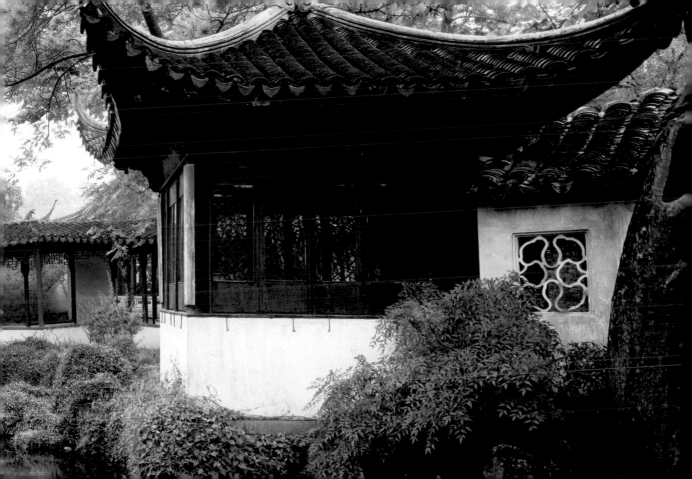

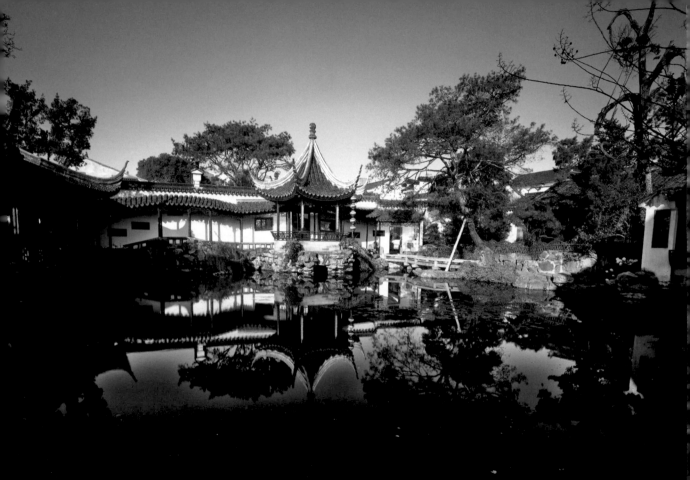

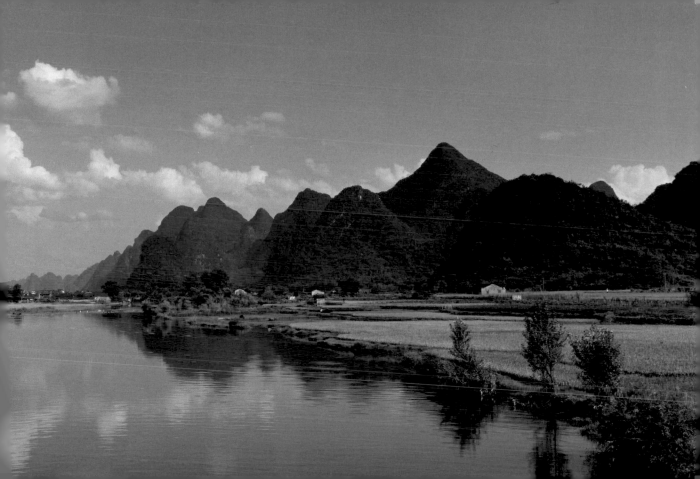

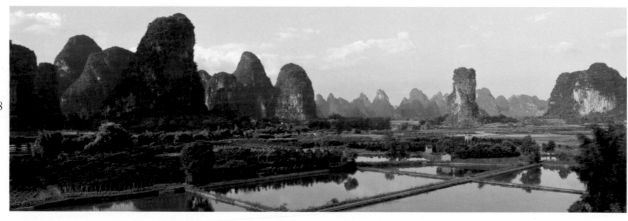

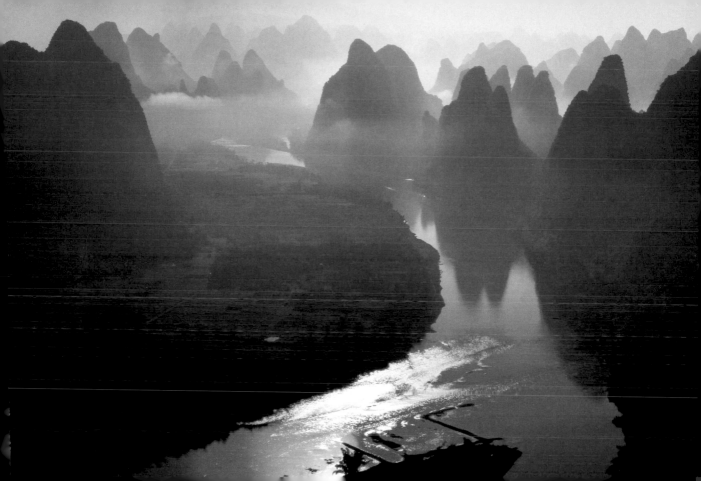

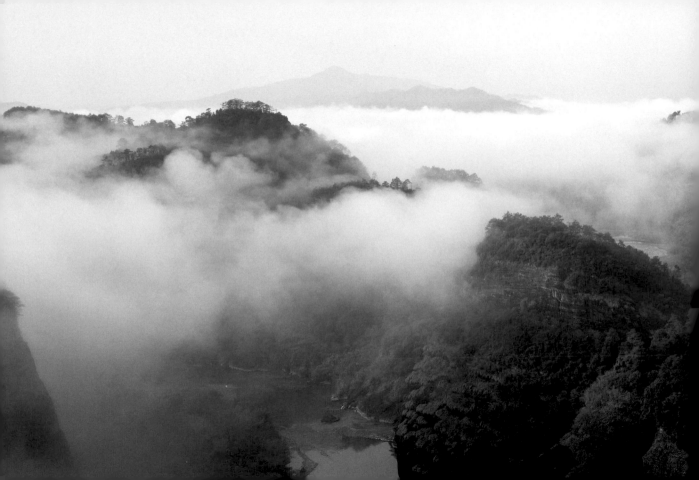

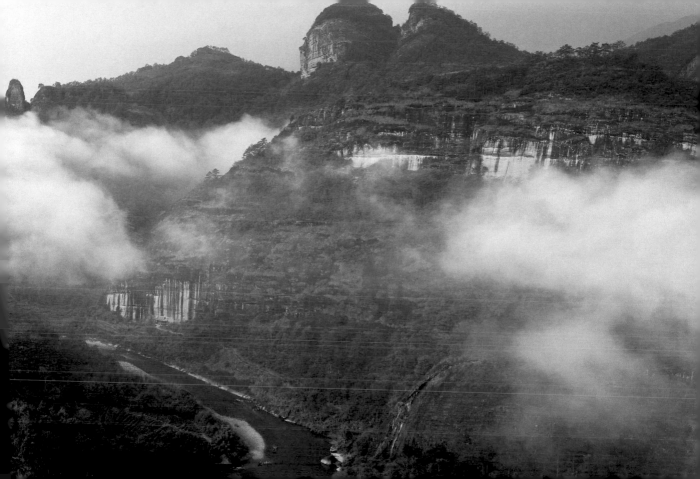

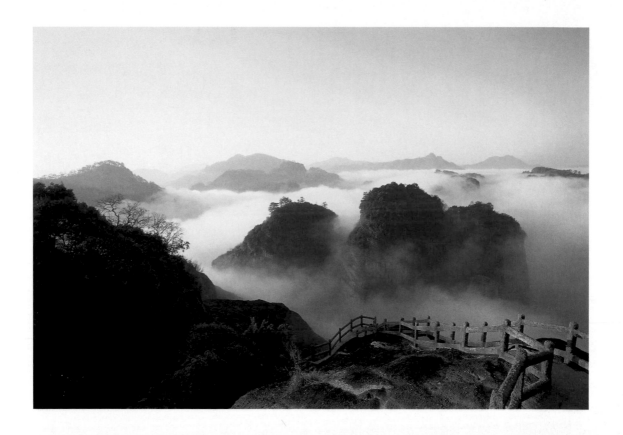

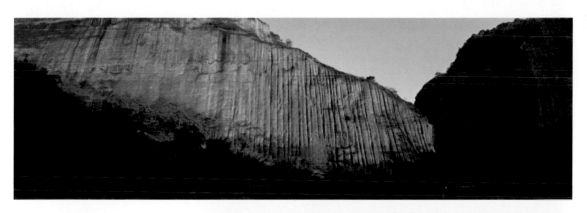

173

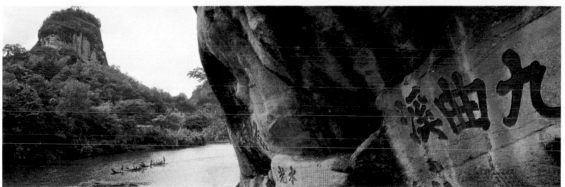

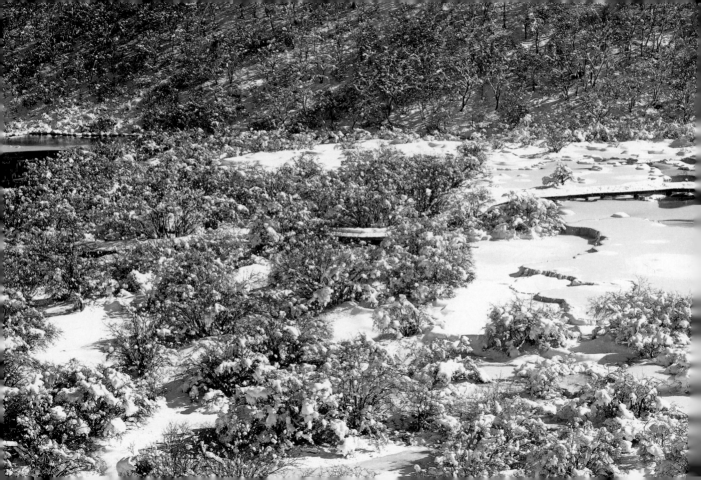

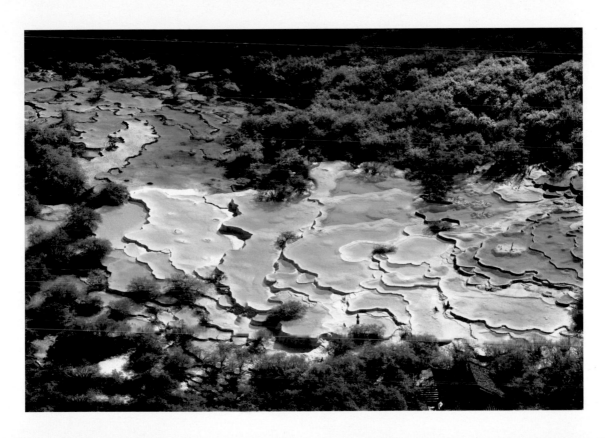

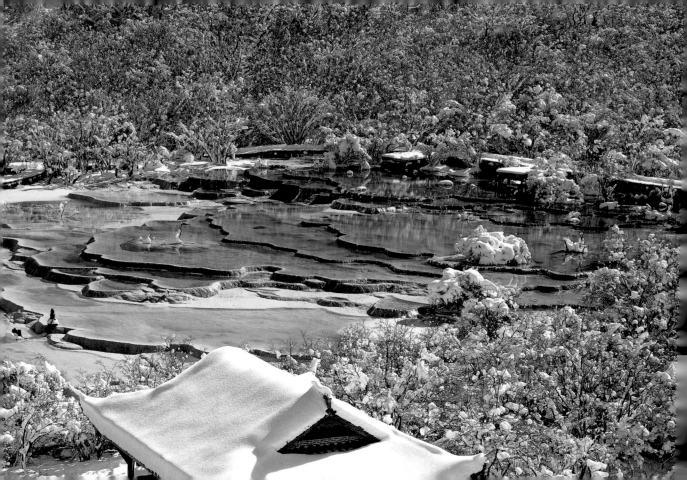

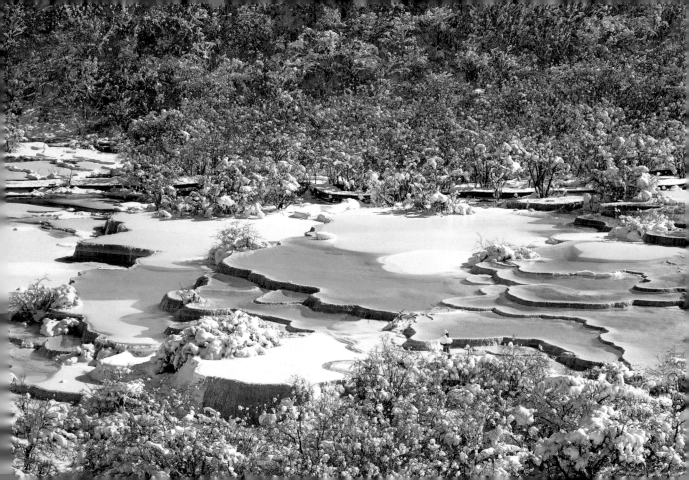

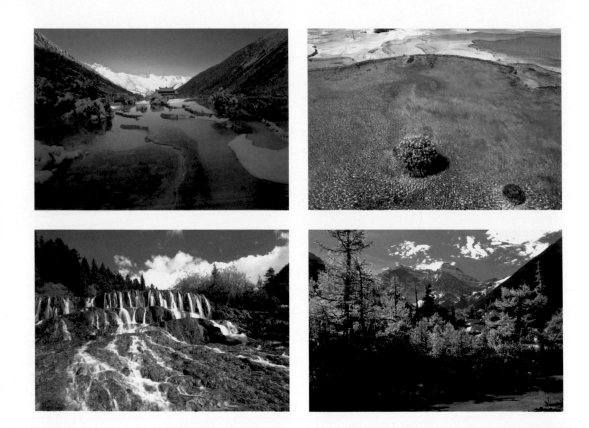

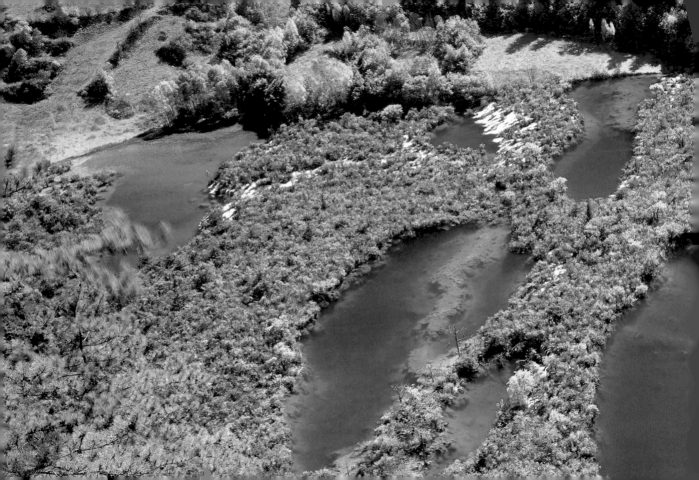

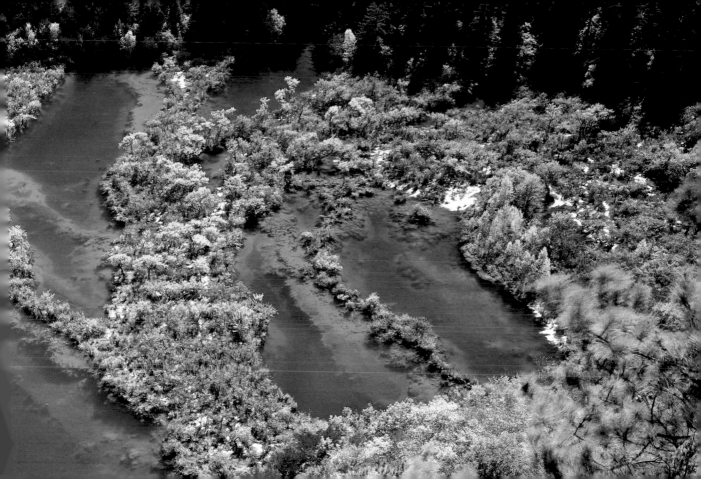

182

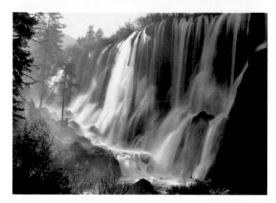

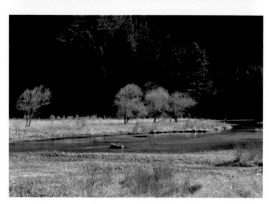

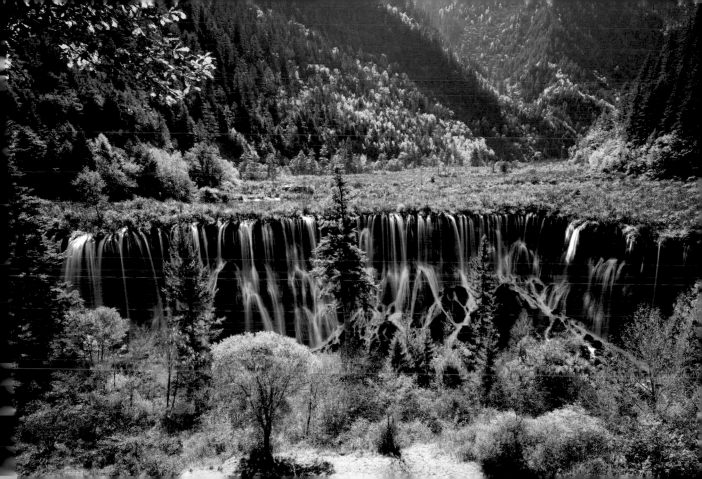

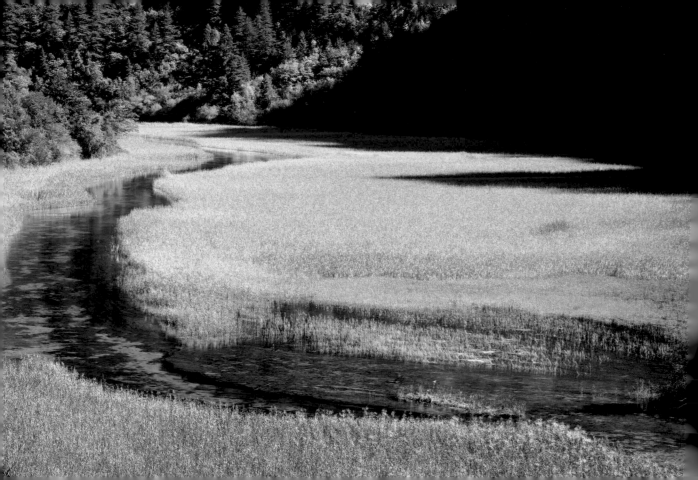

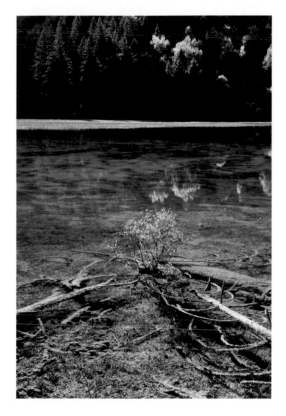

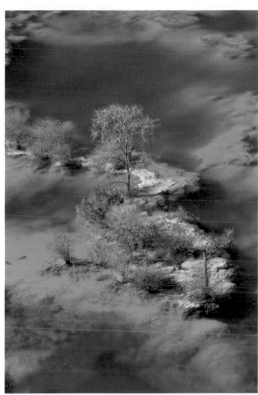

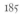

185

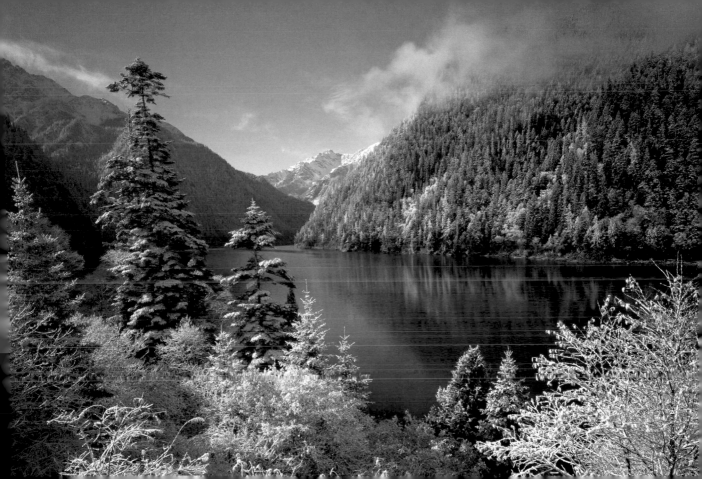

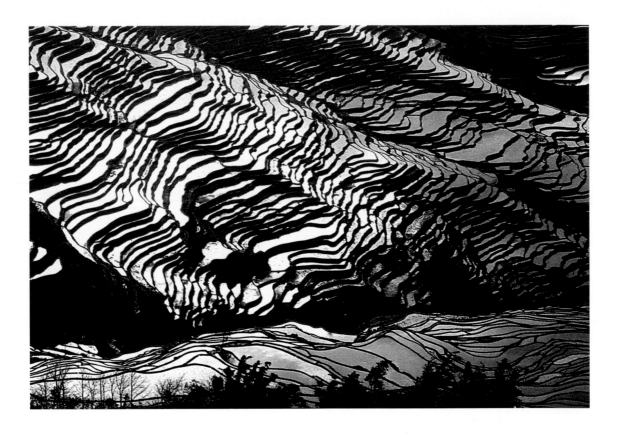

188

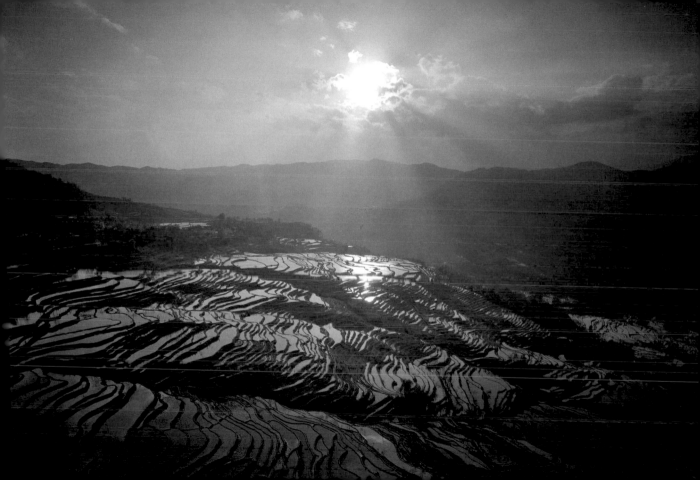

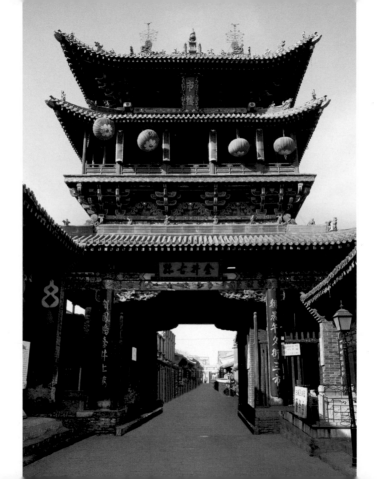

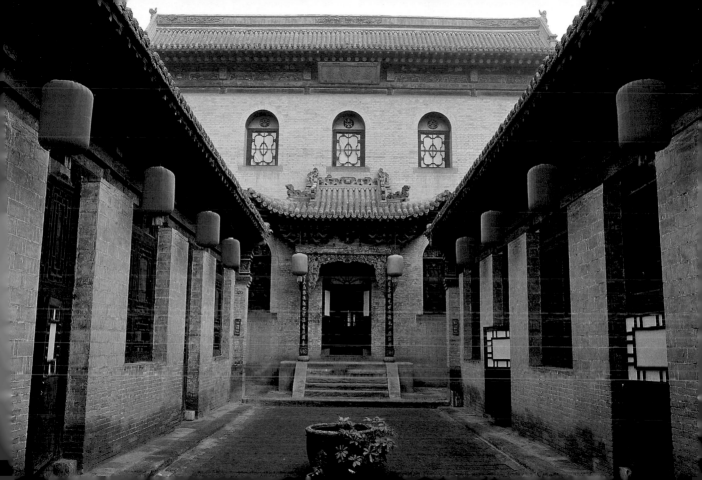

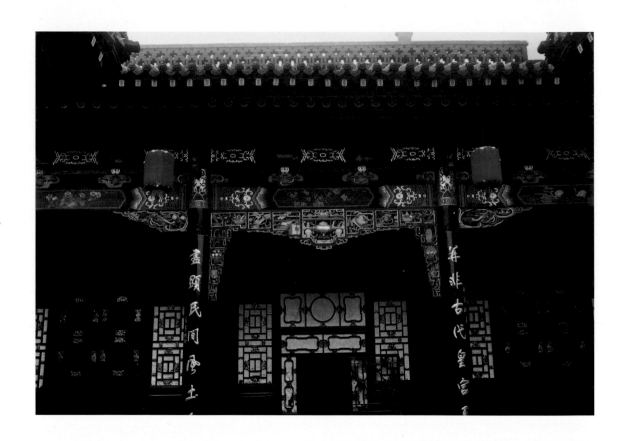

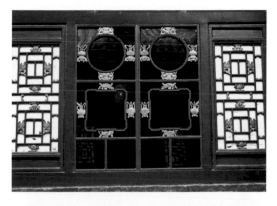

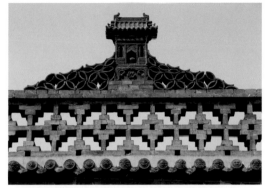

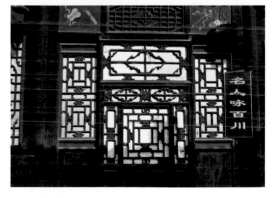

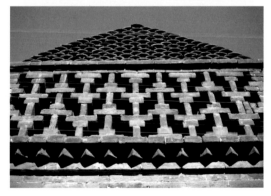

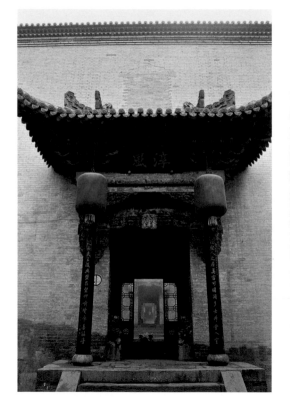

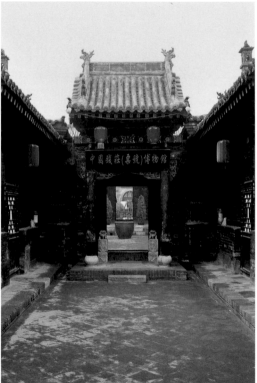

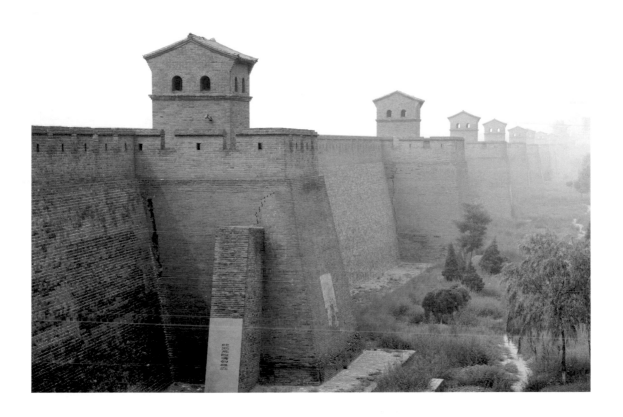

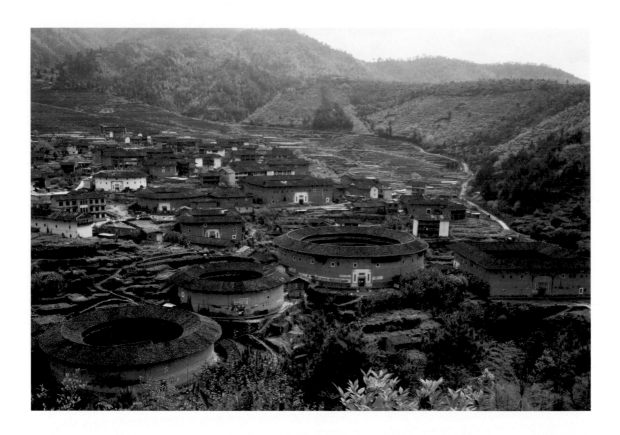

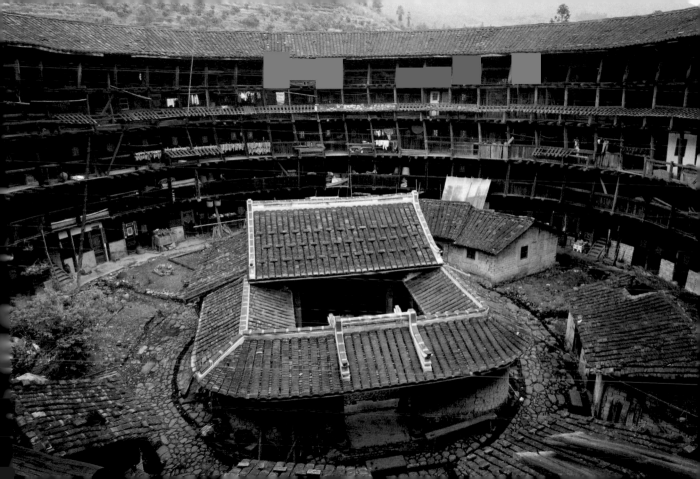

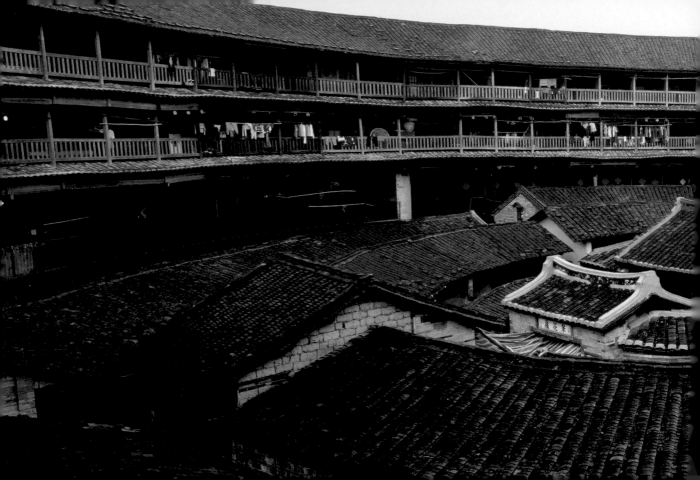

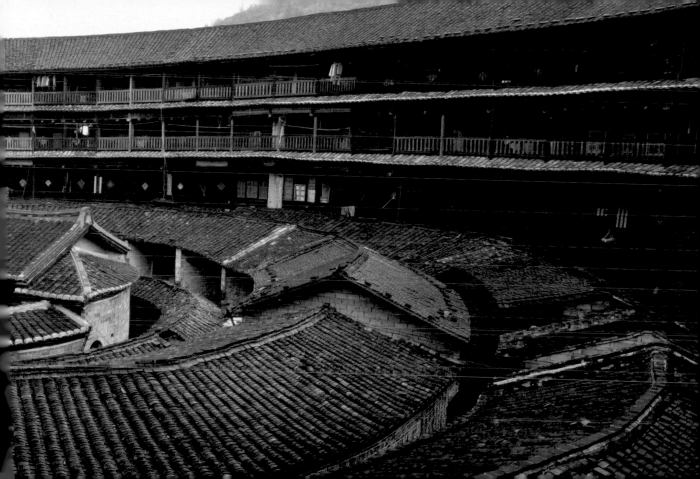

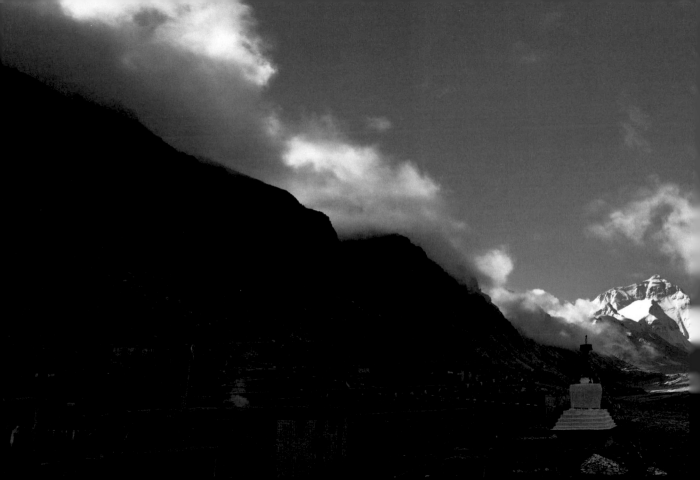

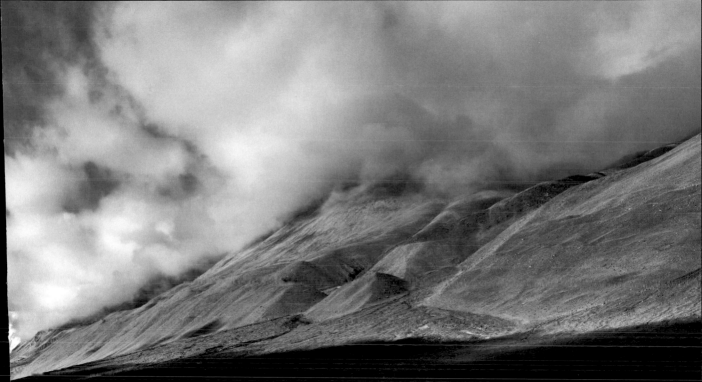

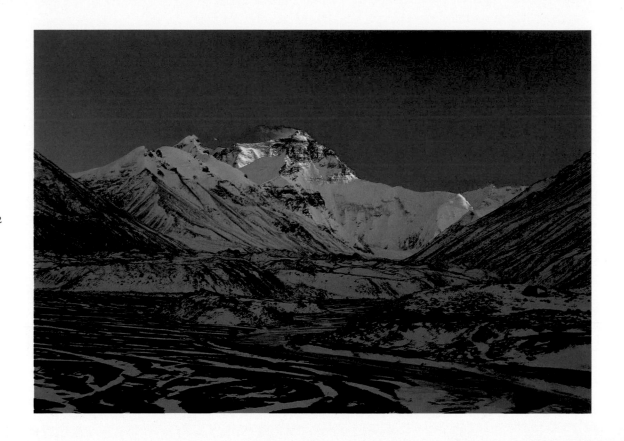

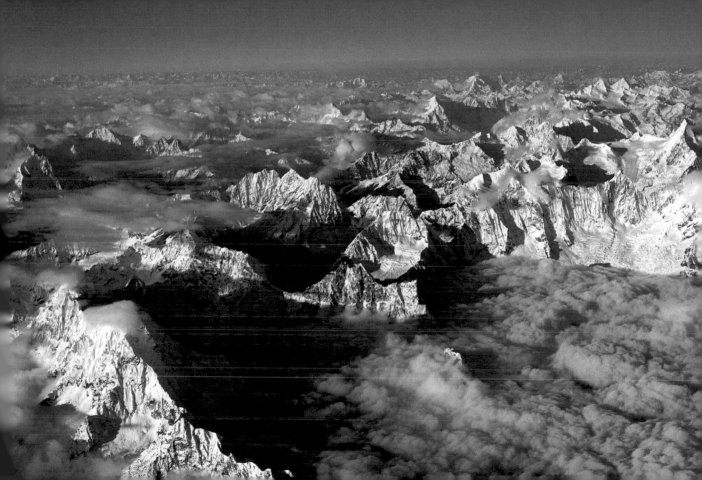

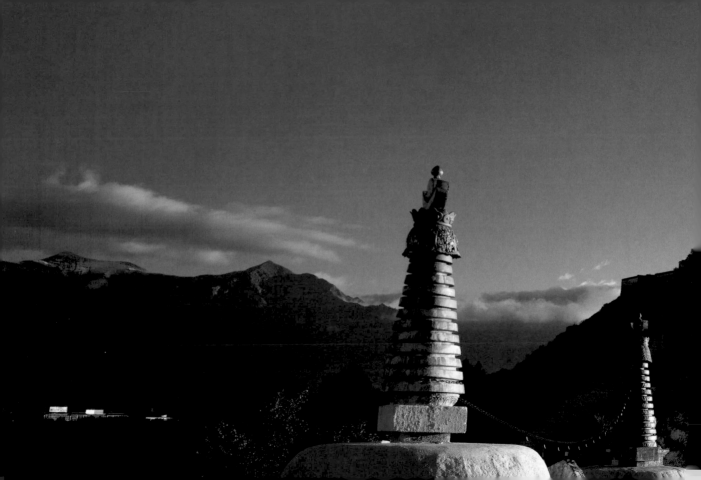

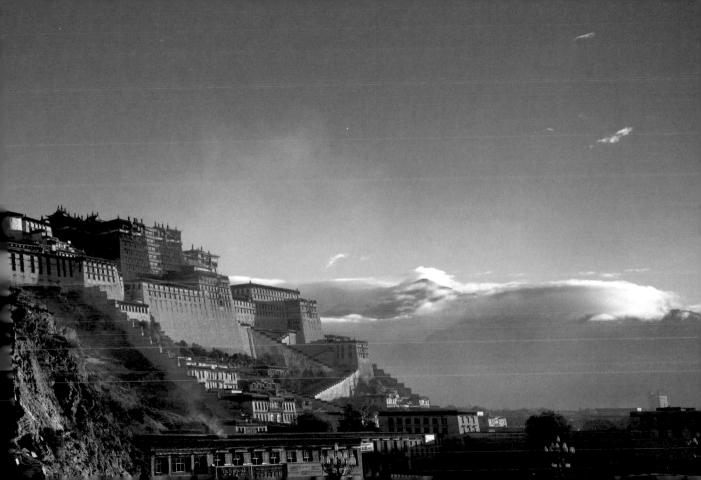

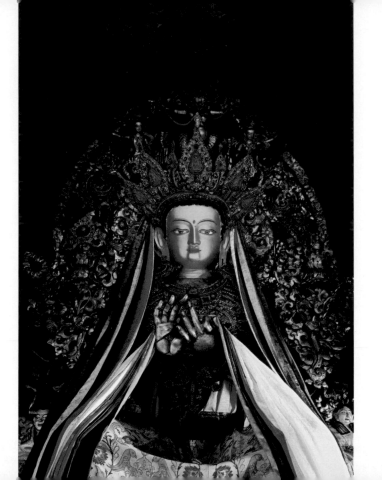

206

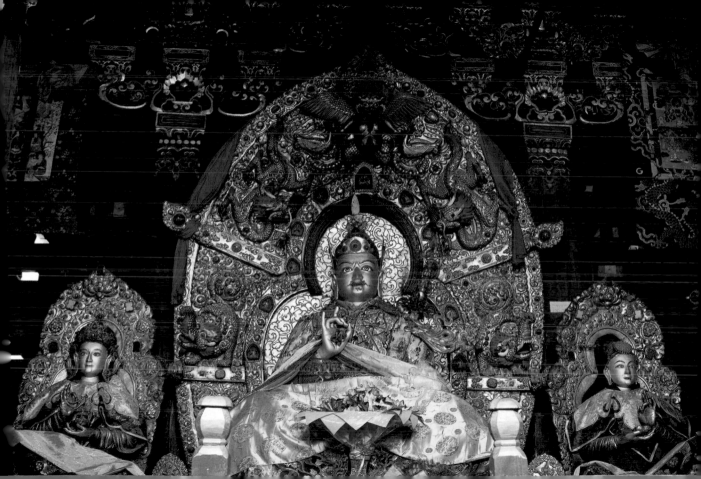

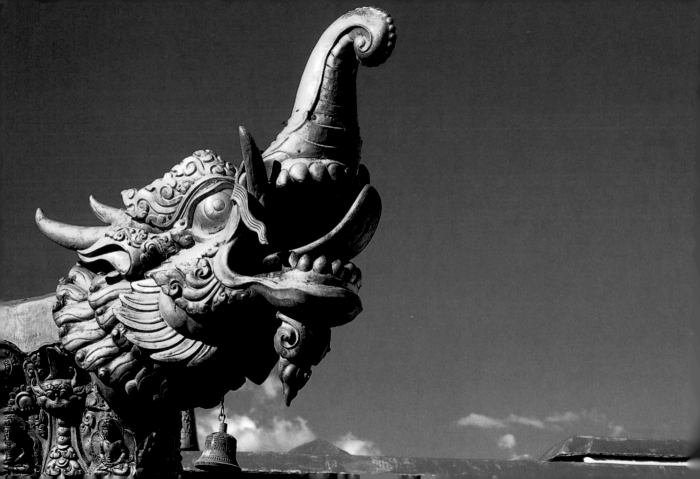

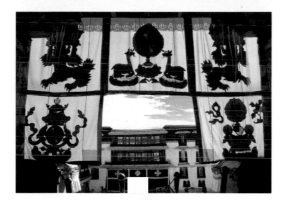

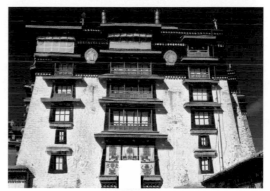

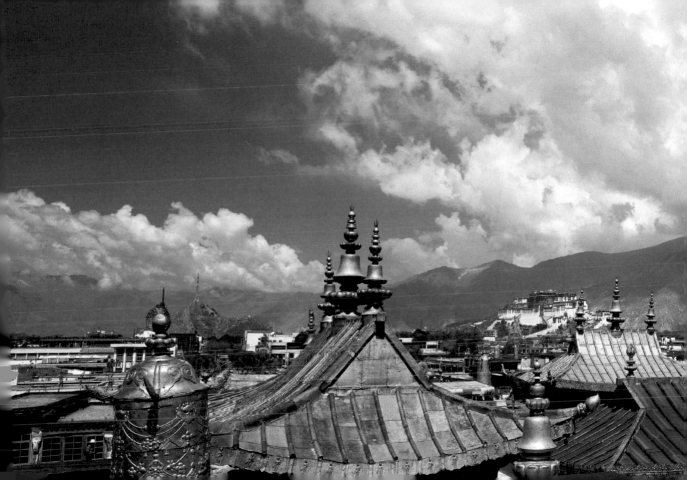

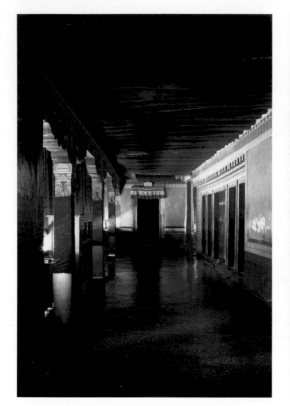

212

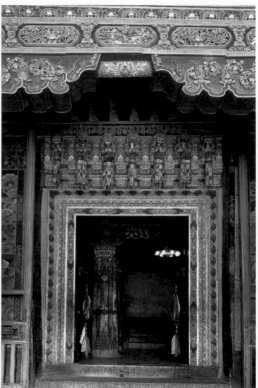

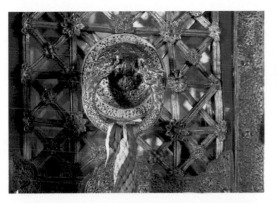

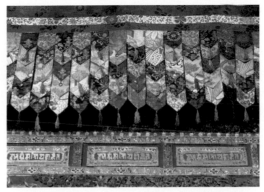

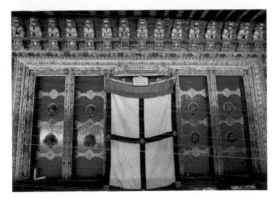

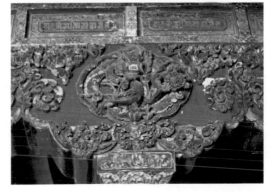

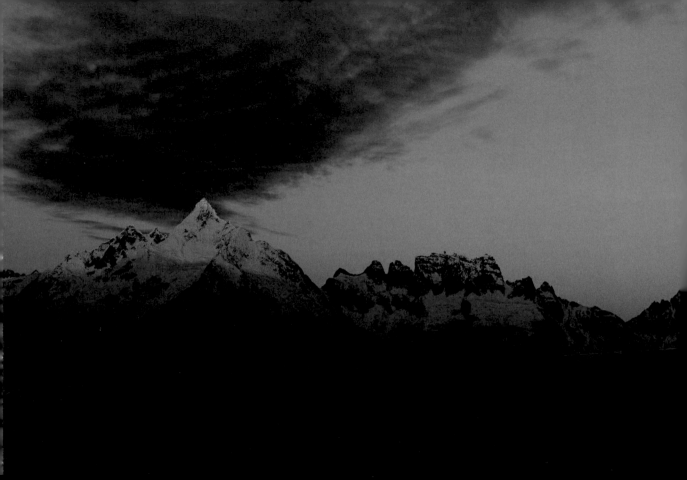

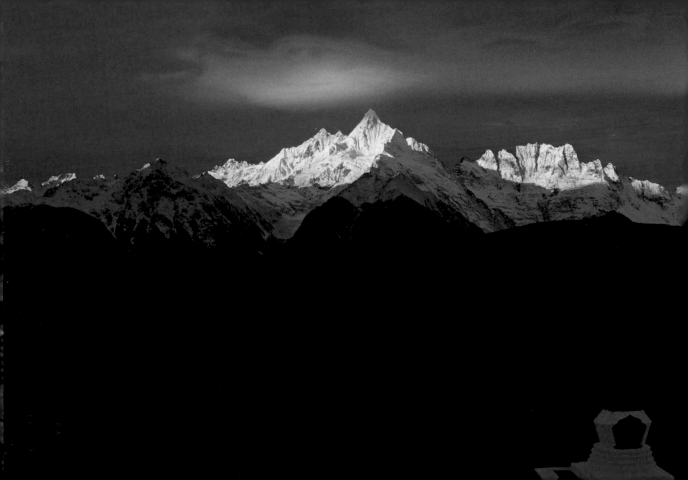

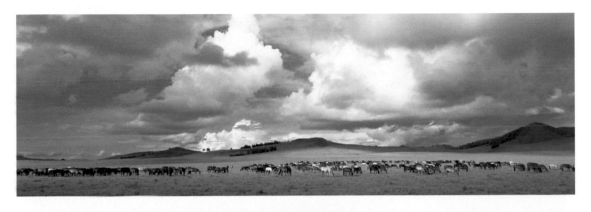

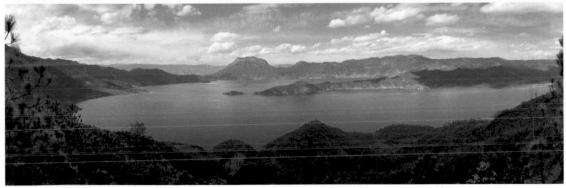

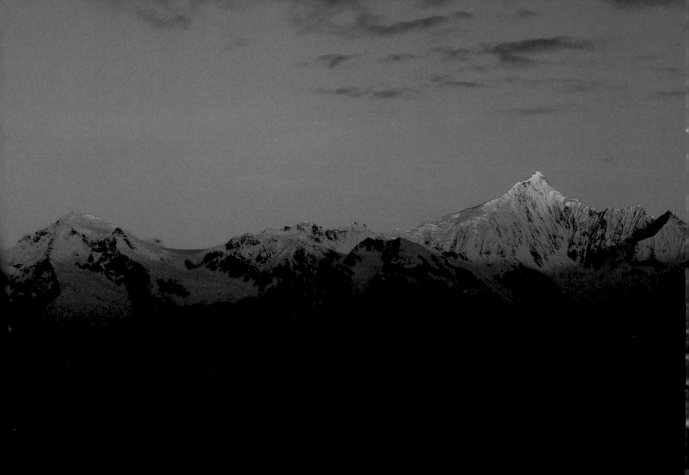

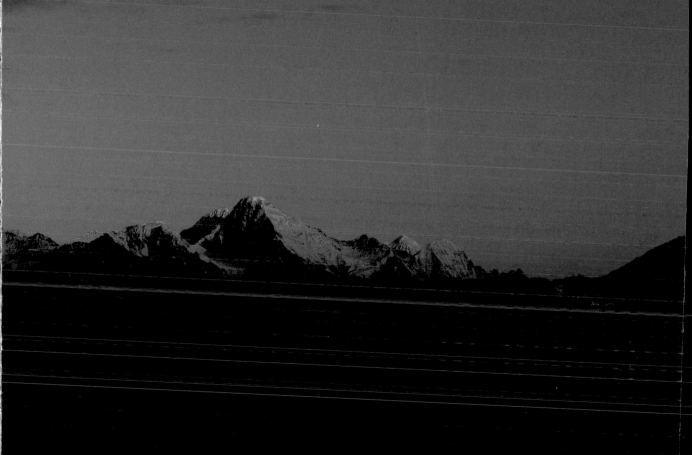

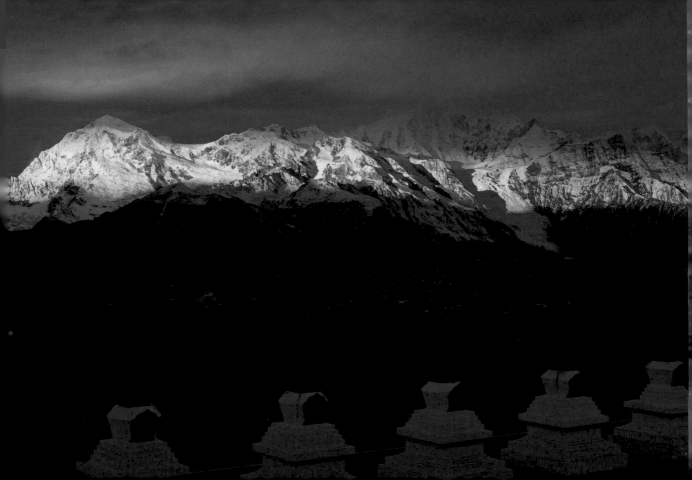

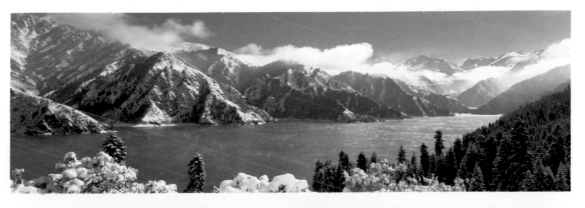

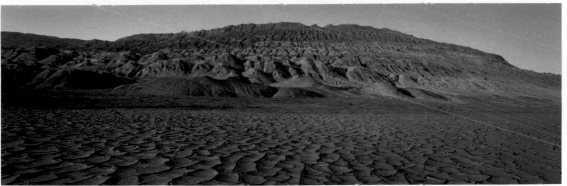

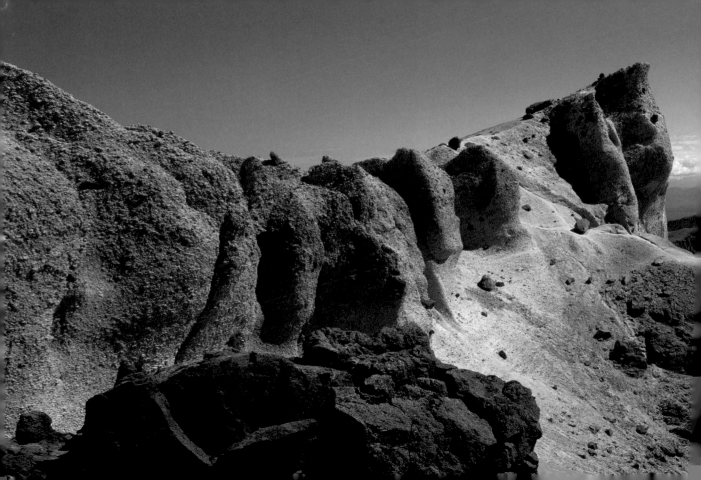

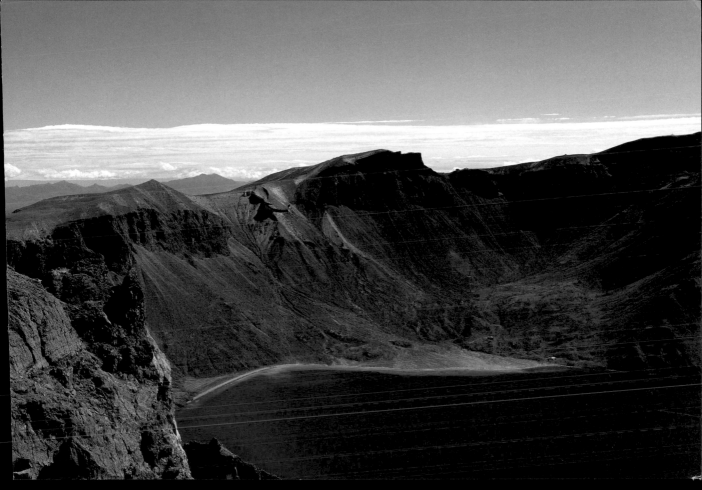

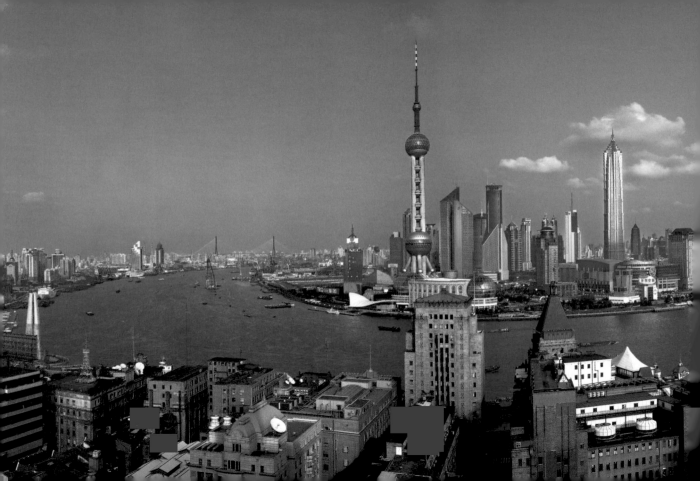

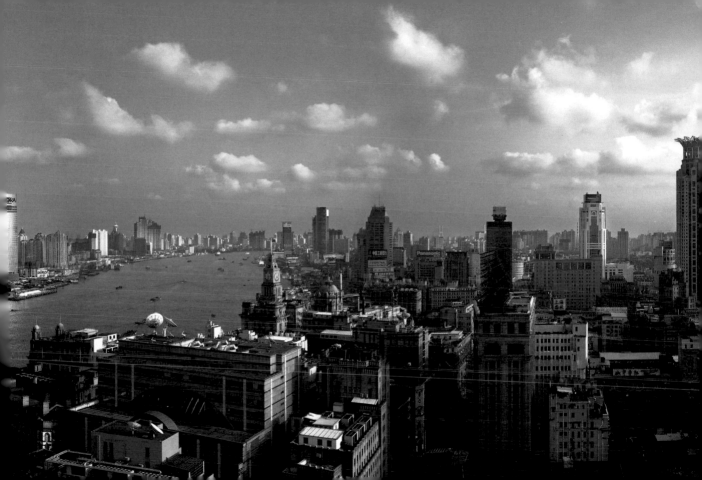

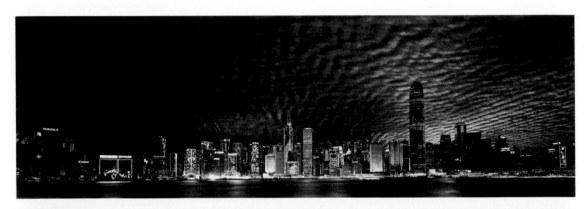

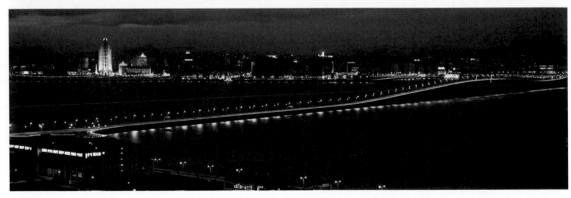

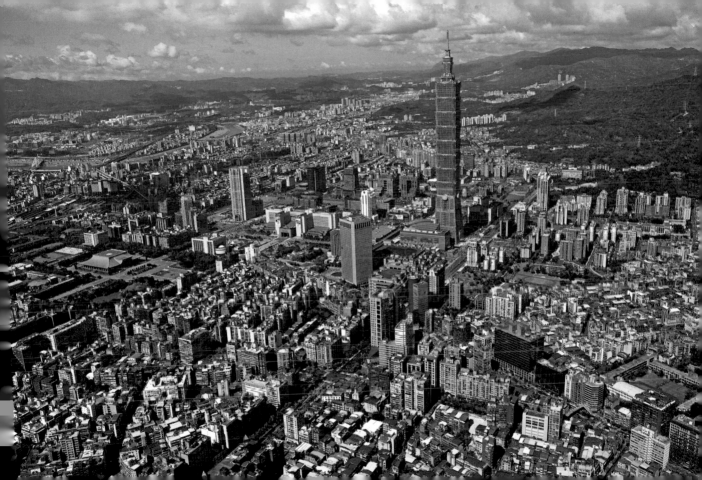

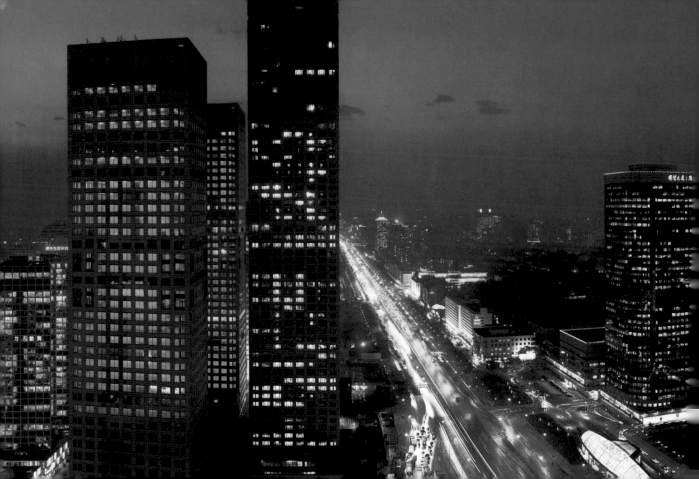

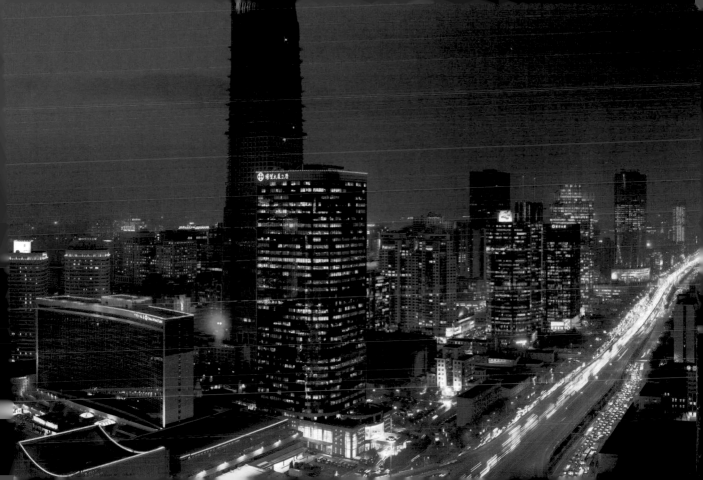

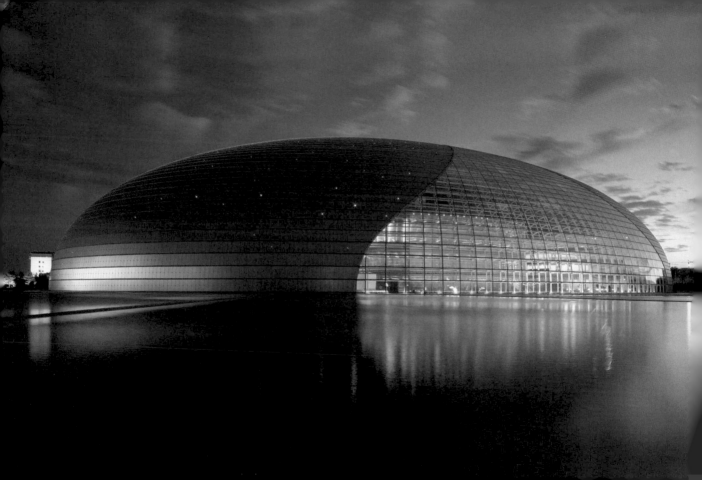

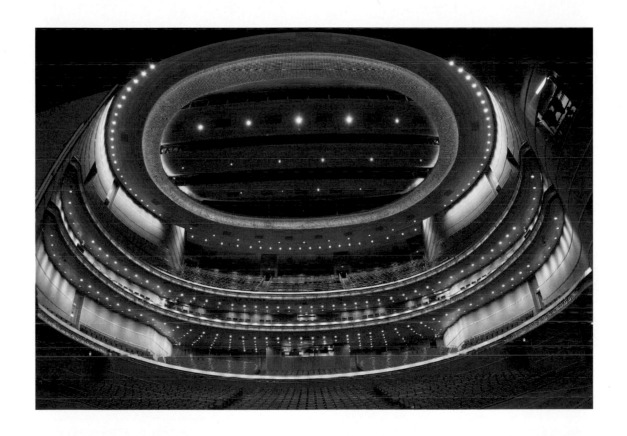

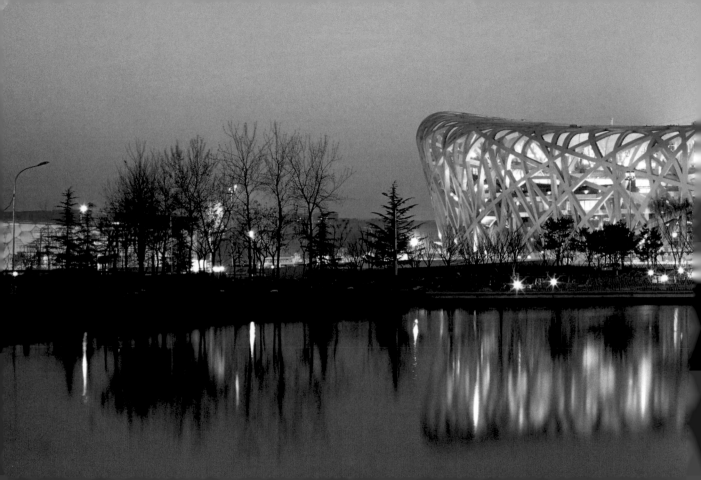

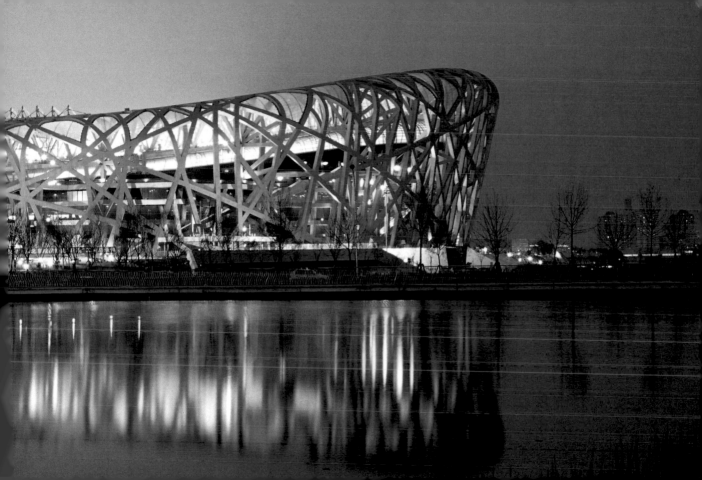

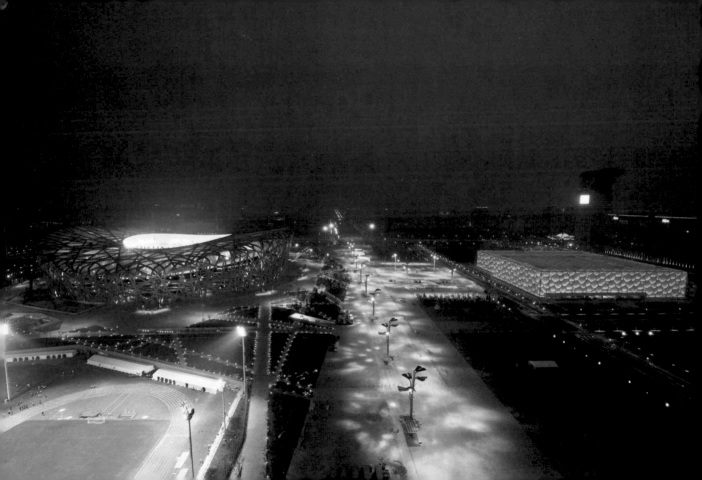

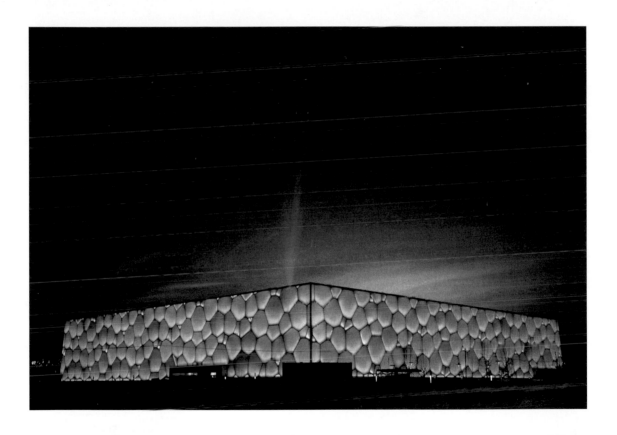

INDEX

The Imperial Palace 1, 11–14, 16–29

The Imperial Palace in Beijing, popularly known as the Forbidden City, was the royal residence of two successive dynasties, the Ming and the Qing, from the early fifteenth to the early twentieth century. The construction of the palace began in 1406–20, during the reign of the Ming emperor Yongle. The scenes of grandeur and serenity to be found within its massive walls silently narrate the rise and fall of China's monarchy over the course of five centuries.

The Forbidden City, the largest and best-preserved imperial palace in the world, is surrounded by a moat some 160 feet (50 m)

wide, and enclosed by a wall over 30 feet (9 m) high. A watchtower rises at each of the four corners of the wall, overlooking the nearly ten thousand chambers and halls inside the city. The principal structures are arranged along a central north-south axis, and the whole complex is divided into two major sections: the Outer Court and the Inner Court. The Outer Court, where the emperors attended grand ceremonies, held audiences, and discussed state affairs with their ministers, includes the Hall of Supreme Harmony, Hall of Middle Harmony, and Hall of Preserving Harmony. The Inner Court, where the emperors handled routine affairs and where their concubines and attendants lived and entertained, includes the Hall of Heavenly Purity, Hall of Union and Peace, Hall of Terrestrial Tranquility, and Imperial Garden.

In addition, the palace houses several thousand works of art, and hence is also the largest museum and treasure gallery in China.

The Great Wall of China

One of the greatest architectural achievements in the history of human civilization, and a symbol of the enduring spirit of the Chinese people, the Great Wall of China was first erected as a defensive barrier during the Spring and Autumn period (722–481 BC) and the Warring States period (475–221 BC). Starting in 214 BC, Qin Shi Huang, the first emperor of the Qin dynasty, spent eight years linking sections of earlier fortifications into a stronger defensive system to protect the northern border against invaders. While the construction of the wall continued off and on until the seventeenth century, most of the present structure dates from

the Ming dynasty (1368–1644). Paved with bricks set in mortar, the walkway of the Ming-era wall is 33 feet (10 m) wide. The total length of the walls built in various dynasties, if joined together, would be 31,000 miles (50,000 km). Like a giant dragon, the great defensive structure follows a winding course over mountains and hills, along the borders of deserts, and across grasslands and rivers.

The Temple of Heaven 42–49

Deeply embedded in the traditional Chinese culture is a reverence for Heaven, Earth, mountains, rivers, the sun, the moon, and the stars. Over the centuries, this primitive worship of nature developed into grand ceremonies of prayer and sacrifice, of which the imperial sacrifice to Heaven was the most important. The place where the reigning emperors of the Ming and Qing dynasties offered their sacrifices to Heaven and prayed for good harvests was the Temple (or, literally, the Altar) of Heaven in the old outer city of Beijing.

First built in the eighteenth year of the Ming emperor Yongle's reign (1420), the Temple of Heaven covers an area of 675 acres (273 ha), about four times the size of the Forbidden City, symbolizing the vastness of Heaven. The main structures within the temple grounds are arranged along the central axis, with the Circular Mound Altar (the proper altar for sacrifices to Heaven) to the south and the Hall of Annual Prayer (the Hall of Prayer for Good Harvests) to the north. The semicircular wall at the northern end of the central axis represents Heaven, and the rectangular one at the southern end represents Earth, reflecting the traditional Chinese belief that "Heaven is round, and Earth square."

In this vast architectural setting, the widely spaced individual structures and the densely clustered pine trees form a sharp contrast that enhances the theme of reverence for Heaven and adds to the temple's solemn atmosphere.

The Summer Palace 50–57

Located in the northwestern suburbs of Beijing, the Summer Palace (literally, the Garden of Peace and Harmony) is the result of renovations made in the fifteenth year of the Qing emperor Qianlong's reign (1860), to an earlier imperial garden. This complex was where emperors of the Qing dynasty spent hot summer days and handled state affairs.

An ingenious use of such natural features as hills and waterways gave birth to the spectacular Kunming Lake. Covering three quarters of the total grounds, the lake is as vast as it is charming. The principal structures, like the Tower of Buddhist Incense on Longevity Hill, stand by the lake and slope down from north to south. More than thirty groups of buildings are either hidden in the forested hills or scattered on the lakeside, creating a vision of earthly paradise. Along the southern foot of Longevity Hill, and parallel to the lake, runs the famous Long Corridor, the longest covered walkway in the world, whose beams and crossbeams are adorned with over 14,000 traditional Chinese paintings on various themes.

In the Summer Palace, the grandeur of north China is ingeniously combined with the elegance of south China, and a perfect harmony is achieved between the man-made and natural features of the landscape.

Chengde Mountain Resort 58-61

For the emperors of the Qing dynasty (1644–1911), Chengde Mountain Resort in north China's Hebei Province, 150 miles (240 km) northeast of Beijing, was a summer retreat, a second political center outside the Forbidden City. Built between the forty-second year of Emperor Kangxi's reign (1703) and the fifty-fifth year of Emperor Qianlong's reign (1790), the Imperial Summer Villa, unlike the walled Forbidden City, offers a naturally peaceful atmosphere.

To take advantage of the site's natural topographic features, four separate scenic sections were laid out from south to north: the Palace, Lake, Plain, and Mountain areas. Mountain ranges, lush forests, green grasslands, plains dotted with misty lakes, and herds of reindeer—all these views contrast with and complement each other. Constructed in diverse architectural styles, the palaces and temples here, though not lavishly decorated, blend harmoniously into the surrounding landscapes.

The Qing rulers, who came from a nomadic tradition, brought with them an appreciation of nature. This finds full expression in Chengde Mountain Resort.

58–59 The Temple of Putuo Zongcheng; dawn at Yanyu Pavilion; afternoon at Yanyu Pavilion
MING TAN

60–61 Eight dragons on the rooftop of the Miaogao Zhuangyan Hall
MING TAN

The Mausoleum of the First Qin Emperor 62-69

The discovery of the terracotta army near the city of Xian, in northwest China's Shaanxi Province, has been hailed as one of the most spectacular archaeological finds of the twentieth century. The army, buried in order to guard the tomb of the First Qin Emperor, is a man-made wonder comparable to the pyramids of Egypt or the Acropolis of Athens.

The terracotta army brings back to the life the grandeur and excitement of a bygone era, when Qin Shi Huang, the first emperor of the Qin dynasty (221–206 BC) and the first unifier of China, was in power. Excavations yielded three large pits (about 215,000 square feet, or 20,000 m², in area) outside this emperor's tomb complex, containing a total of more than 8,000 terracotta warriors, 600 horses, 100 chariots, and some 100,000 pieces of weaponry. Each terracotta warrior stands about 5 feet 9 inches (1.8 m) tall and is made from local clay molded into seven body parts: head, feet, hands, torso, etc. The molded parts were joined together with more clay, and then the details of the face and armor were added. Finally, the warrior was fired in a huge kiln and painted in brilliant colors. Modeled on real soldiers, these life-size figures, whether generals, officers, or rank and file, all have

different facial expressions and postures; they are truly masterpieces of realism.

Imperial Tombs of the Ming and Qing Dynasties
70–75

Viewed from afar, the imperial tombs of the Ming and Qing dynasties are set against heavily forested, rolling mountains; upon closer inspection, it becomes apparent that each burial site is filled with fine relics, lifelike stone carvings, and elaborate decorations.

Among the imperial tombs of the Ming and Qing, those on the World Heritage List include the Ming dynasty Xiaoling Tomb at Nanjing, in east China's Jiangsu Province; the Ming dynasty Xianling Tomb in central China's Hubei Province; the Ming Tombs of Beijing; the Three Imperial Tombs of the early Qing at Shenyang, in northeast China's Liaoning Province; and the Dongling (Eastern Qing) and Xiling (Western Qing) Tombs in north China's Hebei Province. These tombs were all sited, designed, and landscaped so as to conform to the principles of *feng shui* (traditional Chinese geomancy) and to achieve a perfect balance between architecture and landscape. In particular, the following traditional principles were strictly observed: "central location comes first"; "respect seniority"; and "have due regard for precedence."

These extremely lavish and elaborate mausoleums were constructed in the belief that "the afterlife is as real as this life." They form a unique human landscape against the backdrop of nature, a striking illustration of the traditional Chinese worldview and of the power of the last two dynasties of feudal China.

Mount Taishan 76–81

Mount Taishan, a symbol of imperial sovereignty, was an important sacrificial site in ancient China, and its natural splendor and rich cultural heritage are still awe-inspiring today.

Geologically, the mountain was formed as early as the Archean eon, more than two billion years ago, and it bears evidence of human activity dating as far back as the Paleolithic. For over two thousand years, throughout China's feudal history, emperors of the various dynasties traveled to Taishan to pay homage to Heaven and Earth. After Emperor Qin Shi Huang of the Qin dynasty (221–206 BC) and Emperor Wu Di of the Han dynasty (206 BC–AD 220) held grand sacrificial ceremonies on its summit, Taishan gained national recognition as a landmark of everlasting state power. Renowned scholars composed poetry to sing the praises of the mountain, and had their works of calligraphy inscribed on stones, leaving behind a rich legacy of calligraphic art. The more than one thousand stone tablets and cliffside inscriptions that can be seen today all bear witness to their visits. Taishan is also famous for its religious architecture, with Taoist and Buddhist temples, shrines, and historic sites scattered all over the mountain.

76–77 The spot on Mount Taishan graced by Confucius himself
MING TAN

78–79 The winding path up Mount Taishan; inscriptions on Grand View Peak
MING TAN

80–81 Gongbei Rock at Sun-watching Peak; Bixia Temple after a snowfall; towers; Sutra Stone Valley
HUAWEN LI; MING TAN

The Temple, Cemetery, and Family Mansion of Confucius 82–89

The Temple, Cemetery, and Family Mansion of Confucius are all located at Qufu, in east China's Shandong Province. The temple was erected as early as 478 BC to pay homage to Confucius (551–479 BC), the renowned philosopher, statesman, educator, and founder of Confucianism in the Spring and Autumn period. As a result of the successive emperors' devotion to Confucius and Confucianism, the temple was gradually expanded, from the Han dynasty (206 BC–AD 220) onward, into a large complex of 466 halls and chambers. The ten magnificent supporting columns in front of the Dacheng Hall (Hall of Great Achievement), the principal structure within the temple grounds, are carved from single blocks of stone; each depicts two dragons playing with pearls amid a sea of clouds. The Kong Family Mansion, to the east of the Dacheng Hall, is where Confucius's direct descendants lived; it is a fine piece of architecture that served as an official residence and,

at the same time, a private house and garden. Located outside the north city gate of Qufu, the Cemetery of Confucius is where the Sage and his descendants were buried. With more than 100,000 tombs and a history of 2,500 years, it is one of the largest and most ancient graveyards in the world.

The grandeur of these historic structures, which are modeled after the Imperial Palace, reflect not only Confucianism's status as the dominant ideology of feudal China for more than two thousand years, but also the spirit of hierarchy and balance inherent in the Confucian "Doctrine of the Mean."

Mount Lushan 90–93

At Mount Lushan, one of the cradles of Chinese civilization, nature and culture interacted with and complemented each other, creating a place of unique charm. Today the mountain is a popular tourist attraction whose beautiful scenery and historic sites draw millions of visitors.

A lovely yet imposing mountain in east China's Jiangxi Province, Lushan towers over the southern bank of the middle reaches of the Changjiang (Yangtze), China's longest river. It has become a world-famous geological park due to its spectacular features formed by Quaternary glaciations, and is endowed with a uniquely diverse topography of ravines, waterfalls, terraces, and peaks. Lushan is also home to the prestigious White Deer Cave Academy (a study center), as well as a number of historic Buddhist and Taoist temples.

Mount Wudang 94–97

Mother Nature graced Mount Wudang with high peaks, deep ravines, and lush forests. As true worshippers of nature, the Taoists, in their turn, transformed the mountain into an ideal site where they meditated and cultivated themselves.

Located in central China's Hubei Province, Wudang is home to numerous Taoist palaces, temples, monasteries, nunneries, shrines, and courtyards. In this huge complex are represented the great achievements of three dynasties—the Yuan (1271–1368), Ming (1368–1644), and Qing (1644–1911)—in both secular and religious architecture. Ingeniously designed and expertly built, the structures blend seamlessly into the mountainside. The line between architecture and nature is invisible, and the spirit of Taoism and Nature worship can be felt everywhere. "The workman was human; the workmanship, divine"; this is the charm of Mount Wudang.

94–95 *The majestic Purple Heaven Hall*
MING TAN

96–97 *Statue of the Jade Emperor in Purple Heaven Hall; the Dragon Head Incense Burner; the Palace of Supreme Harmony*
MING TAN

Mount Emei and the Leshan Giant Buddha 98–101

Mount Emei and the Leshan Giant Buddha are located about twenty miles apart in southwest China's Sichuan Province. Emei represents a perfect combination of beautiful natural landscapes and rich cultural traditions, while the Leshan Giant Buddha, a symbol of mercy and wisdom, never fails to rejuvenate and inspire.

The natural attractions of Mount Emei—its exceptional location, majestic landscapes, and diverse wildlife—have given rise to a rich cultural heritage that is strongly associated with Buddhism. The first Buddhist temple in China was constructed on the mountain's picturesque summit in the first century AD. Over the centuries, more and more temples were erected around it, turning the mountain into a significant holy site of Buddhism.

The Leshan Giant Buddha was carved out of a mountainside in the eighth century. Overlooking the confluence of three rivers (the Min, Qingyi, and Dadu), this imposing seated figure, the world's largest image of the Buddha, is 233 feet (71 m) tall.

98–99 *Mount Emei emerging from the fog and a sea of clouds; the Golden Summit in snow*
XUEJUN YUAN; DAJUN WANG

100–101 *The Leshan Giant Buddha; detail of the Buddha*
DAJUN WANG; XUEJUN YUAN

Mount Huangshan 102–9

Heaven endowed Mount Huangshan (also known as the Yellow Mountains) with the most spectacular scenery. Visitors are sure to be fascinated by the miraculous workings of nature when they see Huangshan's grotesquely shaped rocks and pines floating amid a sea of clouds.

Situated in east China's Anhui Province, Huangshan owes its unique features to its location and climate, and to the effects of weathering. It is best known for the "four wonders" wrought by Mother Nature: grotesque pines, oddly shaped rocks, seas of clouds, and hot springs. Most of the Huangshan pines grow out of crevices in the rock. The famous Guest-greeting Pine, the symbol of Huangshan, is at least eight hundred years old and is so named because it stretches out a branch as if to welcome visitors. The mountain is composed of granite that has been eroded into pinnacles and fantastic shapes, from which many interesting images spring to the imagination. Seas of clouds, another major attraction of Huangshan, add greatly to its phantasmagoric beauties. Equally noteworthy are the hot springs, clean, pure, and forever bubbling.

Firm, profound, and somewhat aloof, Huangshan's natural landscape displays the qualities that the ancient Chinese admired most. Indeed, there is no more fitting landmark of traditional Chinese culture than Huangshan.

102–3 *The scenic spot of Beihai shrouded in clouds*
YONGFU ZHANG

104, 107 *The Guest-greeting Pine, perching stone, strange stone*
YONGFU ZHANG

105–6 *Stone Monkey watching the sea of clouds*
YONGFU ZHANG

108–9 *Shixin Peak; Yuping Peak in snow; Shixin Peak in a sea of clouds; a sea of clouds at Mount Huangshan*
YONGFU ZHANG

Mount Qingcheng and the Dujiangyan Irrigation System 110–13

Located in southwest China's Sichuan Province, to the south of the Dujiangyan irrigation system, Mount Qingcheng is famous for its beautiful scenery and Taoist temples. Its heavily forested hills and evergreen trees have earned it the title of "the Most Secluded Place under Heaven." The temples here are cleverly designed to take advantage of the mountain's topography, and most are constructed in the traditional style, symmetrically arranged along a central axis. Taoism's profound reverence for nature finds full expression in these ancient buildings.

The Dujiangyan irrigation system was initiated on the western edge of the Chengdu plains as early as the third century BC,

in order to control the waters of the Minjiang River and irrigate the plains. This gigantic engineering project was completed by thousands of laborers under the guidance of Li Bing, a governor of the Shu administrative region of the Qin dynasty, and his son. The oldest surviving no-dam irrigation system in the world, Dujiangyan is a splendid example of Chinese engineering. The system has benefited the farmers in the neighborhood of Minjiang immensely for more than 2,200 years, functioning perfectly up to the present day.

Wulingyuan 114–17

A scenic area in the northwestern part of south China's Hunan Province, Wulingyuan is renowned for its "three thousand fantastic peaks and eight hundred beautiful waterscapes."

During the Middle and Late Devonian period, large volumes of quartz sandstone were deposited at Wulingyuan, where the sea and the land meet. The movement of the Earth's crust and the weathering process cut some highlands into peaks, and others into valleys and ravines. Then nature filled in these fascinating landscapes with thick forests, swirling clouds, and countless brooks, springs, lakes, pools, and ponds.

Like a traditional Chinese landscape painting, the green mountains and blue waters of Wulingyuan combine to create a setting of primeval natural beauty and rich artistic charm.

The Mogao Caves 118–23

The Mogao Caves, known as "the largest treasure house of Buddhist art in the world," are located on the cliffs of Mount Mingsha (the Singing Sand Dunes), near the city of Dunhuang in northwest China's Gansu Province. Dunhuang, once a hub of the Silk Route, was not only a center for trade between China and the outside world, but also a melting pot where different cultures and religions came together. The construction of the Mogao Caves began in AD 366, during the Jin dynasty (265–420), reached its peak during the Sui (581–618) and Tang (618–907) dynasties, and continued into the Song (960–1279) and Yuan (1206–1368) dynasties.

Carved into the 50 to 100 foot (15 to 30 m) high cliff walls are 735 caves, 492 of which shelter polychrome statues and wall paintings from various periods, numbering more than 3,000 in all. The statues, whose style progresses from the Indo-European to the more purely local, graphically illustrate the evolution of Buddhist art in China. The colorful wall paintings, which depict the Buddha's life and donor figures, would have a total length more than ten times the perimeter of the Forbidden City's wall if they were joined end to end.

Over the centuries, the endless caravans of the Silk Route and the streams of pilgrims have faded from view, leaving behind only the images in these caves to offer a hint of Dunhuang's bygone glory.

The Dazu Rock Carvings 124–31

The creation of the rock carving at Dazu began as early as the Tang dynasty and the Five Dynasties period (907–960) and continued into the Ming and Qing dynasties. Chiseled out of the steep cliffs, the carvings include outstanding examples of sculpture from the period in the ninth to twelfth centuries that marked the transition from image-making in caves to that on cliffs.

Situated in the city of Chongqing, in southwest China's Sichuan Province, Dazu comprises some one hundred sites with a total of well over fifty thousand carvings, which each display the styles of their respective eras: gracefully rounded in the Tang dynasty, exquisitely fine in the Five Dynasties period, and well proportioned in the Song dynasty. These masterpieces feature both secular and religious themes; some vividly portray idyllic scenes from the everyday life of local villagers. More importantly, the Dazu carvings combine Buddhism, Taoism, and Confucianism into one, exemplifying the harmonious coexistence of these three major religions.

The Longmen Grottoes 132–35

Situated on a riverside terrace near the city of Luoyang in central China's Henan Province, the Longmen Grottoes are considered one of China's top three examples of Buddhist cave art, the other two being the Mogao Caves and the Yungang Grottoes.

Most of the grottoes and niches of Longmen were carved between the Northern Wei and Tang dynasties (386–907), and were usually sponsored by the royal families, nobles, and dignitaries. The earliest statues were chiseled under royal patronage in 494, the eighteenth year of the Northern Wei emperor Taihe's reign. Of all the carvings, those in Fengxiansi Cave are the most spectacular. A giant statue of Vairocana Buddha sits in the middle of this cave, surrounded by carefully placed smaller figures that gaze at each other. Legend has it that the Buddha was modeled after Empress Wu Zetian (r. 684–705). Dignified and imposing, but at the same time wearing the trace of a gentle smile on the slightly upturned corners of his mouth, this Buddha is one of the prime examples of Tang dynasty sculpture.

In ancient times, Indian art exerted a profound influence on the sculpture of the border areas of China. When the earliest of the Longmen Grottoes were carved in the Wei and Jin dynasties, this imported culture met, and clashed with, the more established Han culture. From an aesthetic standpoint, however, the images of the Longmen Grottoes are distinctly Chinese, and fully representative of the traditional Chinese art of stone carving.

The Yungang Grottoes 136–41

The Yungang Grottoes are located at the foot of Wuzhou Mountain, west of the city of Datong in north China's Shanxi Province. Carved during the reigns of the Northern Wei emperor Wencheng (452–465) and his successors, these masterpieces represent the outstanding achievement of Chinese cave art in the fifth and sixth centuries AD.

The 252 grottoes and niches of Yungang house a total of 51,000 statues. Of all the grottoes, the Five Caves cut by Tan Yao, a

Buddhist monk, are believed to be the earliest, and also the most typical of those that display the influence of Indian and Persian art. Since Emperor Wencheng decreed that the stone images be modeled after the emperor, it is felt that the carvings of this period have an air of absolute sovereignty, and thus represent a breaking away from the earlier copies after Western models. In the later Yungang carvings, however, the images became more secularized as the Chinese sculptors developed a greater self-awareness.

136–37 Panorama of the Yungang Grottoes; two exterior views of the grottoes; pillars in Grotto No. 6; the sitting statue of Sakyamuni in Grotto No. 20
MING TAN; PANORAMIC PHOTO GALLERY

138–39 The sitting statue of Sakyamuni in Grotto No. 20; the statue of cross-legged Maitreya Buddha in Grotto No. 13
MING TAN

140–41 Pagoda in Grotto No. 11; pillars in Grotto No. 6; the North Wall in the front chamber of Grotto No. 9
MING TAN

The Villages of Xidi and Hongcun 142–47

The Ming and Qing dynasties (1368–1911) were prosperous times for the merchants of east China's Anhui Province, many of whom returned to their native villages to build or renovate their houses. Many such houses are preserved in Xidi and Hongcun, which are considered the most representative ancient villages of Anhui. In these two villages, the original streetscapes have been left largely intact, and numerous ancient homes are clustered around the ancestral temples, creating ideal habitats that harmonize with the surrounding natural environment.

Flanked by two streams, the village of Xidi takes the shape of a boat. All the streets in the village run along the streams, and 124 elegant traditional houses have been preserved from the Ming and Qing periods. The village of Hongcun was laid out in the shape of an ox, and now retains one residence from the Ming period and 132 from the Qing. Each family had the stream water channeled into their own house for their use. The layouts of the two villages, in the shapes of a boat and an ox, embody the concept of the oneness of man and nature that is emphasized in the traditional Chinese culture.

142–43 View of idyllic Hongcun Village
MING TAN

144–45 Xidi Village surrounded by mountains; two details of the villagers' houses
MING TAN; SHAOBAI LI

146–47 Moon Pond in Hongcun Village, so called because of its half-moon shape
MING TAN

The Old Town of Lijiang 148–55

Ever since the publication of Joseph F. Rock's articles in *National Geographic* and James Hilton's novel *Lost Horizon*, Lijiang, in southwest China's Yunnan Province, has fascinated people around the world.

Built more than eight hundred years ago, the old town of Lijiang is strategically located at the junction of Yunnan, Sichuan, and Tibet. Due to its important military position, it rapidly grew into a major town along the ancient Silk Route and Tea-Horse Road. Over the centuries, Lijiang was a hub for cultural and economic exchanges between the Han, Tibetan, Bai, and Naxi peoples. The influence of these different ethnic groups helped to shape the local Naxi culture of this charming and prosperous town, which is nestled in a timeless land of mountains and rushing rivers.

148, 153 View of Yulong Snow Mountain from the Black Dragon Pool; two views of the water supply system; street scene
MING TAN

149–52 Bird's-eye view of the old town
MING TAN

154–55 Panorama of the old town
MING TAN

The Classical Gardens of Suzhou 156–65

Chinese gardens fall into two principal categories: the imperial and the private. The former, usually grand and lavishly decorated, are located mostly in Beijing, in north China, while the finest examples of the latter, exquisitely small, neatly laid out, and artistically landscaped, are found in the city of Suzhou, in south China.

The history of the classical gardens of Suzhou can be traced back to the gardens of the King of Wu in the Spring and Autumn period, although the earliest documented private garden was built in the fourth century AD. In the Ming and Qing dynasties, Suzhou developed into one of the most prosperous cities in China. Private gardens could be found everywhere, both inside and outside the city wall; at its peak, Suzhou had more than two hundred of them. Unfortunately, only a few dozen have been preserved in good condition.

Suzhou's classical gardens, which re-create natural landscapes in miniature, feature a delightful combination of pavilions, terraces, towers, fountains, hills, flowers, and trees. Although some were scenic, temple, or scholar gardens, most were intended for private residential use; they were spaces where people could relax, entertain, and live comfortably. Today, in a densely populated city where green space is fast disappearing, these gardens are valued

more than ever as truly creative expressions of the love of beauty and harmony with nature.

Lijiang River 166–69

Lijiang River is the soul of the splendid scenic region around the city of Guilin, in southwest China's Guangxi Zhuang Autonomous Region.

The river, its banks dotted with peaceful towns and picturesque villages, weaves its way like a silver ribbon through a karst landscape of forests and craggy peaks. And the river's charm varies with the seasons: the reflection of blue peaks in the sun is just as enchanting as the view, through a dreamlike veil of mist, of distant hills in the rain.

While a cruise on the Lijiang will bring visitors in touch with its unique scenery, a walk along the riverbank will introduce them to the age-old traditions and customs of the local people. For hundreds of years, ethnic minorities like the Zhuang, Yao, and Miao have inhabited the area along the river, and their unique folkways have added immensely to its beauty.

Mount Wuyi 170–73

Legend has it that as early as the Tang Yao era, some 4,500 years ago, Peng Zu (Ancestor Peng) took his two sons, Peng Wu and Peng Yi, to northern Fujian, where they dug canals in a mountain to divert floodwaters. To commemorate the two sons, their descendants named this mountain Wuyi, a combination of their names.

Mount Wuyi is a fine illustration of the traditional Chinese principle of the coexistence of man and nature; in fact, the

mountain is an archaeological site that has been deliberately preserved for more than twelve centuries. Its significant architectural remains include a number of temples, a Han city established in the first century BC, and the ancient academies, or study centers, associated with the Neo-Confucianism of the eleventh century AD. The academies attest to Wuyi's status as the cradle of this intellectual movement, which played a dominant role in the philosophy and government of the countries of eastern and southeastern Asia for many centuries.

170–71 The beautiful Jiuqu River
MING TAN

172–73 Mount Wuyi; Clothes-drying Rock; Jiuqu River
PANORAMIC PHOTO GALLERY; MING TAN

Huanglong Valley 174–79

Set between snow-capped mountains and China's easternmost glaciers, Huanglong Valley features diverse and dramatic karst landforms.

In this beautiful scenic area of southwest China's Sichuan Province, towering peaks and glaciers rise above mysterious forested hills and secluded, winding gullies. The valley is dotted with a veritable museum of travertine formations of various sizes: there are as many as 3,400 colored travertine pools; a

travertine waterfall 306 feet (93 m) long; a travertine shoal 4,265 feet (1,300 m) long and up to 560 feet (170 m) wide; and countless travertine springs, terraces, and caves.

174–77 Five-color Lake in winter; Five-color Lake in autumn
DAJUN WANG

178–79 Five-color Lake in snow; Five-color Lake close up; travertine falls; pond; Moon Reflecting Pond
DAJUN WANG

Jiuzhaigou Valley 180–87

Located in southwest China's Sichuan Province, the Y-shaped Jiuzhaigou Valley holds 114 lakes, 17 multi-tiered waterfalls, 47 springs, and 11 rapids. These interconnected waters descend more than 3,300 feet (1,000 m) through peaks, forests, and gorges. This spectacular scenery is enhanced by the valley's diverse ecosystems and plant species. For example, the aquatic flora of the lakes, dominated by spirogyra, charophyta, and parkeriaceae, bring a rich variety of colors to the waters: clear blue, dark green, and orange-red. A designated nature reserve, Jiuzhaigou is also home to a number of endangered animal species, most notably the giant panda and the Sichuan takin.

The valley is framed by majestic snow-clad peaks, as high as 13,000 feet (4,000 m), which contrast wonderfully with the

brilliantly colorful lakes, whose beauty is as easy to enjoy as it is hard to define.

The Terraced Fields of Yuanyang 188–89

In the 1990s, Yann Layma, a French photographer, published a collection of photographs entitled "Mountain Sculptors of Yunnan," depicting the terraced fields of Yuanyang County, hidden deep in the Ailao Mountains of south China's Yunnan Province. Since then, these terraced fields, the world's most spectacular, have attracted many other photographers, and thousands of tourists.

The cultivators of the terraced fields of Yuanyang are the Hani people, an ethnic group who migrated to the frontiers of Yunnan some one thousand years ago. When the ancient Hani found that the valleys of this region were not suitable for growing crops, they decided to turn the mountainsides into rice paddies by piling up soil into ridges and then channeling the water of mountain springs into the resulting terraces, which are located 4,300 to 5,900 feet (1,300 to 1,800 m) above sea level.

The centuries of hard work that the Hani put into creating their system of terraced fields, which they still farm today, is a testimony not only to the enduring traditions of Chinese agriculture, but also to the human spirit.

The Historic City of Pingyao 190–95

One of the best-preserved county seats of ancient China, Pingyao was a major financial center during the Ming and Qing dynasties. Its historic cityscape, which dates from the fourteenth to nineteenth centuries, is important to the study of all aspects of the cultural heritage of the Han people.

The recorded history of this fortified city in north China's Shanxi Province goes back as far as the Western Zhou period (1046–771 BC). The old city wall, built over six hundred years ago in the Ming dynasty, has remained virtually intact. The historic buildings, particularly the county magistrate's office and the six

large temple complexes, look as impressive today as they did when they were first built. Within the city wall is a network of more than one hundred streets and lanes lined with shops, most constructed between the seventeenth and nineteenth centuries. The city's 3,797 traditional houses, which are decorated with exquisite carvings in wood, stone, and brick and with paper cutouts, are the best-preserved examples of the traditional residential architecture of the Han.

190–91 City Tower; the courtyard of a house
XUEJUN YUAN; MING TAN

192–93 Painted wood carvings on a house; views of house windows and decorative brickwork on houses
MING TAN; XUEJUN YUAN; PANORAMIC PHOTO GALLERY

194–95 The gateways of two houses; the old city wall
MING TAN; XUEJUN YUAN

The Fujian Tulou 196–99

Built mostly in the southwest part of east China's Fujian Province, the Tulou (literally, "Earthen Houses") are the structures in which the local Hakka farmers have lived for hundreds of years.

During the late Tang and early Song periods, some one thousand years ago, large groups of Hakka fled south from China's central plains to avoid the dangers of war. Calamities and famines drove them on to what is today southwest Fujian. Desperate for a warm, safe home, they built gigantic castles by pounding clay, sandstone, bamboo, and wood chips into massive walls. Fire- and waterproof, earthquake-resistant, sunny, and well ventilated, these fortified structures protected the Hakka from unwanted intrusions. And in the event of war, the Tulou, with wells and barns inside, could provide the dwellers with enough food and water for months.

A circular Tulou, which is considered the most representative type, looks like a strongly fortified military castle from the outside. But step inside and you will see that it is warm, comfortable, full of life, and home to a large family of several hundred Hakka.

196–97 Tulou; interior view of a Tulou
MING TAN

198–99 Interior view of a Tulou
MING TAN

Mount Everest 200–203

The Himalayas, the world's highest and largest mountain range, extend more than 1,490 miles (2,400 km), varying in width from 90 to 250 miles (150–400 km). Mount Everest, the highest peak in the Himalayas, and in the world, rises 29,016 feet (8,844 m) above sea level on the border between Nepal and Tibet. Shaped like a gigantic pyramid and full of power and grandeur, Everest

has become the holy site for all mountain worshippers. Three of the peaks surrounding Everest also rise to heights of well over 26,000 feet (8,000 m) above sea level. Nowhere else can you find such a chain of towering mountains; hence the Himalayas are also known as "the Roof of the World."

The Potala Palace 204–13

The spiritual center of Tibetan Buddhism and the administrative seat of successive dynasties, the Potala Place in central Lhasa is Tibet's most majestic and best-preserved palace complex. Its history began as early as the seventh century AD, when Princess Wencheng, the daughter of a Tang dynasty emperor, arrived in Tibet to marry Songtsen Gampo, ruler of the Tubo Kingdom. Legend has it that Gampo built a castle on the Red Mountain, the site of the present-day Potala Palace, as a wedding gift. After Gampo, nine rulers of the Tubo Kingdom and ten successive Dalai Lamas of Tibet lived in this castle complex.

The current form of Potala dates from the reign of the fifth Dalai Lama, Ngawang Lobsang Gyatso, who rebuilt the castle in the mid-seventeenth century, shortly after the Qing emperor conferred an honorific title on him. Repeated expansions by later Dalai Lamas eventually turned this castle into an architectural complex comprising two principal palaces: the Red and the White. The Red Palace, in the center, is where religious activities take place and the holy stupas of successive Dalai Lamas are enshrined. The U-shaped White Palace contains the living quarters where Dalai Lamas once handled political affairs.

The Potala Palace houses a wealth of murals and cultural relics, all masterpieces of religious art. Together with the architecture of the palace complex, these artifacts graphically chronicle the storied history of the Tibetan people.

The Three Parallel Rivers 6–7, 214–19

The Three Parallel Rivers is the name of the mountainous region in southwest China's Yunnan Province where three mighty rivers —the Yangtze (Jinsha), the Lancang (Mekong), and the Nujiang (Salween)—run almost parallel to each other on a southward course for over 105 miles (170 km). These rivers, all originating on the Qinghai-Tibet Plateau, roar down through snowy mountains and deep gorges, creating spectacular scenery.

Some forty million years ago, the Indian tectonic plate collided with the Eurasian plate, and the Hengduan Mountains were uplifted, compressed, and incised, resulting in the geological wonder of the Three Parallel Rivers. The region is blessed with such diverse topographic features as snowy mountain canyons, glacial meadows, and, most notably, the alpine Danxia landforms (red calcareous sandstone of the Tertiary period eroded by wind and water). It is also home to a remarkable diversity of wildlife.

Tianchi Lake on Mount Changbai 222–23

Located in northeast China's Jilin Province, Mount Changbai (literally, the Perpetually White Mountain) is famous for its virgin forests and massifs of volcanic rock. Over the centuries, successive eruptions of the mountain's volcano have formed the sixteen snow-capped peaks that surround its crater. Meanwhile, water has accumulated in the basin-like depression of the crater itself, creating Tianchi, or the Lake of Heaven, which straddles the border of China and North Korea. With an altitude of 7,050 feet (2,150 m), Tianchi is one of the highest crater lakes in the world; it is now as beautifully calm as the volcano was once explosively violent.

China's Cities 224–35

The cities pictured here are the ones most representative of China. Some are ancient, and some fairly modern, but each of them

has its own distinctive character. Beijing, for example, gives an impression of grandeur—which is reinforced by its newest architectural marvels—but at the same time is full of the pressures and struggles of modern life. Shanghai seems gently exquisite by contrast, but excitement and energy pervade everywhere. Although it is the most dynamic and vibrant multicultural cosmopolis of China, Hong Kong also offers truly serene settings in such areas as Qianshuiwan and Chizhu. Macao witnessed, on the one hand, the spread into China of Western religious culture and, on the other, the introduction into the West of the folk religions of China, such as the worship of Mazu (the Chinese sea goddess). And while there are many historic spots and scenic places in Taipei, a bird's-eye view of the city reveals towering skyscrapers and the neverending flow of traffic.

First published in the United States of America in 2010 by
Abbeville Press, 137 Varick Street, New York, NY 10013

First published in the United Kingdom in 2008 by CYP
International Ltd., 79 College Road, Harrow, Middlesex,
Greater London HA1 1BD

First edition in this trim size
10 9 8 7 6 5 4 3 2 1

ISBN 978-0-7892-1080-7

A previous edition of this book was cataloged as follows:
Library of Congress Cataloging-in-Publication Data
China / chief editor, Guang Guo ; chief photographer, Ming Tan.
—1st ed.
 p. cm.
1. China—Pictorial works. 2. Landscape—China—Pictorial
works. 3. World Heritage areas—China—Pictorial works.
I. Guo, Guang. II. Tan, Ming, 1950–
 DS706.3.C4625 2009
 951.0022′2—dc22

 2009010411

For bulk and premium sales and for text adoption procedures,
write to Customer Service Manager, Abbeville Press, 137 Varick
Street, New York, NY 10013, or call 1-800-ARTBOOK.

Visit Abbeville Press online at www.abbeville.com.